IMAGES
of America

SKOKIE

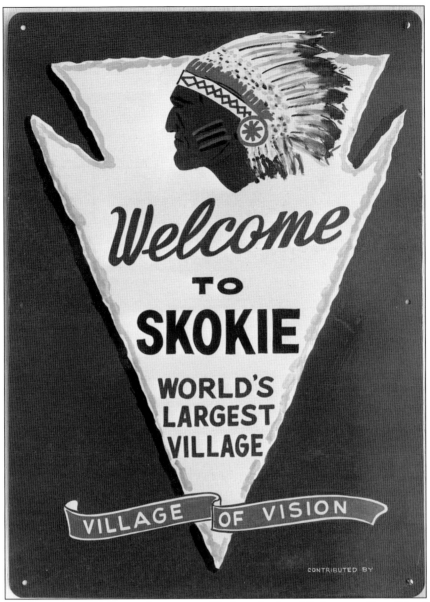

The sign pictured above welcomed visitors to Skokie, the "world's largest village," in the early 1960s. At the time, Skokie wrested the title of largest village from Oak Park. The 1960 census revealed Skokie's population to be 59,364, up from 14,752 per the 1950 census, an increase of over 300 percent. The arrowhead and Native American in headdress are symbols of Skokie's Native American past. (Courtesy of Skokie Historical Society.)

ON THE COVER: Members of the Niles Center community celebrate at Klehm's Picnic Grove in downtown Niles Center (Skokie) in the early 1900s. Among the celebrants are members of the Niles Center Athletic Club and the Niles Center Volunteer Fire Company. A common location for picnics and parties, Klehm's Picnic Grove was located on the southwest corner of Oakton Street and Lincoln Avenue behind Klehm's store. The Bank of America building currently occupies this site. (Courtesy of Skokie Historical Society.)

IMAGES
of America

SKOKIE

Amanda J. Hanson
and Richard J. Witry

ARCADIA
PUBLISHING

Published by Arcadia Publishing
Charleston SC, Chicago IL, Portsmouth NH, San Francisco CA

Printed in the United States of America

Library of Congress Control Number: 2009943318

For all general information contact Arcadia Publishing at:
Telephone 843-853-2070
Fax 843-853-0044
E-mail sales@arcadiapublishing.com
For customer service and orders:
Toll-Free 1-888-313-2665

Visit us on the Internet at www.arcadiapublishing.com

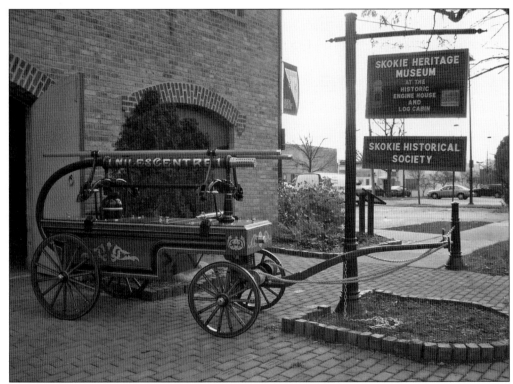

This book is dedicated to all members and volunteers of the Skokie Historical Society who, over the years, so lovingly collected the images, which have been our privilege to present to you, the reader. Pictured above, taken in front of the Skokie Heritage Museum and home of the Skokie Historical Society, is the original 1865 Rumsey pumper. Purchased in 1881, this recently restored piece of equipment can be seen in the photograph of the Niles Center Volunteer Fire Company on page 25. (Courtesy of Skokie Historical Society.)

CONTENTS

ACKNOWLEDGMENTS

When presented with the opportunity to publish this work, we wondered from where the support would come. After all, both of us have full time jobs and family obligations. However, as we progressed, our task became easier when several friends and colleagues stepped forward to aid us in this endeavor.

First and foremost, we must thank the officers, members, and volunteers of the Skokie Historical Society, past and present, who have so efficiently, over the last 25 years or so, collected, cataloged, and lovingly preserved more than 8,000 pictures and artifacts in the collection. Without their efforts, this work would not have been possible. Special thanks to Pres. Ron Smith and volunteers Patti Witry, Aaron Reisberg, and Sherwin Schwartz, each of whom have spent thousands of hours in the effort. Please note that, unless otherwise indicated, all photographs and documents are courtesy of the Skokie Historical Society.

Since the advent of the partnership between the Skokie Historical Society and the Skokie Park District, the district has given generous support to the efforts of the society in preserving Skokie's history. At no small cost, the district has preserved the Skokie Heritage Museum and Log Cabin. Kudos to Pres. Mike Reid and his fellow commissioners, director Mark Schneiderman and recreation superintendent Michelle Tuft, for their unstinting support of the society. Thanks are also due to the marketing staff at the district for their help in shaping and cropping images and to Angela Graham, Ed.D., retired AP English teacher from Niles West High School, who took the time to review our work to ensure its grammatical and stylistic integrity.

Most historical collections suffer from a lack of recent photographs and artifacts, as people do not consider that which we do today as either interesting or historical—yet those very things we find uninteresting are tomorrow's history. To help us tell the tale of today's Skokie, we sent John Zouras of John Zouras Photography on a journey into the village to take photographs. His marvelous images grace the last chapter of this book.

We especially wish to thank our families, Stephen and Joanne Hanson and Patti Witry, for allowing us the time to devote to this mission. It cannot be gainsaid that without their understanding, this work would not have seen the light of day.

We hope you enjoy viewing Skokie's history through the prism of these photographs as much as we enjoyed selecting and presenting them to you.

Richard J. Witry and Amanda J. Hanson
May 2010

INTRODUCTION

Sayings, those certain phrases that capture the moment in a most succinct manner, roll from our lips daily. They do not need many words to convey their meaning. That is why they are used. One of these old saws emerged from early 20th century America. "A picture is worth a thousand words." How true! In this picture book, over 200 images are presented that depict the lifeblood of the village for the period from 1760 to the present. If the saying is true, then this work is equal to 200,000 words, which, in turn, is the equal of an 800-page novel with 250 words per page. Eight hundred pages is a lot of story to tell, yet the story of Skokie is told here in only 126 pages.

What is Skokie's story? Well, it is a cultural journey that starts with a period in which no Europeans were present. The Mascouten and Potawatomi were Native American tribes that emerged from Canada in the 1500s. Both groups were part of the Algonquin-speaking Native American nations that populated the lower Great Lakes region. The Potawatomi were present in this area until removed to the west by federal fiat in the 1830s. The Frederick Scharf map of Native American settlements shown on page 11 illustrates various settlements in this area. Niles Center Road and Lincoln Avenue were birthed as Indian trails. Unfortunately, aside from the road grid, the only physical traces we have that remind us of their presence are arrowheads, which have periodically been found as the village developed.

Once the Potawatomi were relocated west of the Mississippi, the area became ripe for migration from the east. The next period, which commenced around 1840, is evidenced by the westward movement of the eastern seaboard settlers into *skokey*, a Potawatomi/Mascouten word meaning "marsh." From the earliest settler, a bachelor named O'Brien who set up his lean-to at present day 4920 Oakton Street, Western Europeans, primarily from several of the Germanic states and Luxembourg, dominated this area until the early 1950s. A village grew up in the heart of Niles Township, which became known, not surprisingly, as Niles Centre. Built between two railroad lines, one in Evanston and the other in Morton Grove, Niles Centre grew into a farm community whose residents sold flowers, vegetables, and other staples to one another and to the large city to the south. Around 1910, the English spelling of "centre" gave way to the Americanized "center," and in 1940, Niles Center became Skokie.

When World War II ended and the United States was preeminent in the world, migration from the big cities to the suburbs began in earnest. Aided by the construction of the Edens Expressway, groups from Chicago's south and west sides with ties to Eastern Europe and the Middle East began converging on Skokie. The Jewish migration to Skokie had begun and, like a sea change, has left its imprint on the village. Marked by the construction of temples and synagogues, where only churches had been present, Skokie's faith culture was changed from a predominantly Catholic and Protestant one to a Catholic, Protestant, and Jewish culture. In the neighborhoods, Christmas trees and multicolored lights were joined by Stars of David and blue lights.

Since approximately 1980, the most recent waves to land on our shores have come from the Indo-Asian community of nations. Filipinos, Pakistanis, Indians, and others from the Far East

have joined their European cousins in shaping our community into the village in which we live and work today. That Skokie is a polyglot mixture of cultures and religions is best demonstrated by the Skokie Festival of Cultures, which is held each year at the end of May. Dozens of cultures are represented at this annual festival designed to celebrate the diversity of our community.

Each of the chapters contain images that reflect the story. In chapter one, a picture of the great Potawatomi chieftain Shabbona reminds us of our long forgotten ties to the Native American peoples who settled this area. One Skokie park is named after Shabbona. In chapter two, the pictures of horses, buggies, vacant land, taverns, and dirt roads remind us of our pioneer days when families named Harms, Hermes, Klehm, and Blameuser settled in Niles Centre. The Wild West is also remembered in the films of the Essanay Company, shot here between 1905 and 1915. In chapter three, old-timers named Krier and Lies continue to make their mark on the village; 20th century advances are captured in the images of wooden buildings moved to make way for brick and mortar, horseless carriages replacing the horse and buggy, and farmland giving way to subdivisions. Sports like bowling started to appear. In chapter four, the suburbanization of America is portrayed in pictures of paved roads and traffic lights on roads where, just years before, none were necessary. Before long, amusement parks appeared, and the park district began building swimming pools. Those paved roads made it much easier for families to migrate from their city enclaves to Skokie. In chapter five, evidence that America is indeed a melting pot is shown in the faces of those who come from the Indian subcontinent and Far East. These newcomers, by living and working in present day Skokie, join the sons and daughters of the Western European and Middle Eastern immigrants who have called Skokie home for 150 years. In selecting these images, the hope is to convey to the reader a measure of those tidal influences that have shaped Skokie since the arrival of the Potawatomi.

One

THE POTAWATOMI AND MASCOUTEN

1500s TO 1840

This map shows the maximum extent covered by the Potawatomi nation in the lower Great Lakes region prior to the Indian Relocation Acts enacted by Congress in the late 1820s. Subsequent to 1812, as settlers from the east moved into the Illinois prairie, the Potawatomi engaged in skirmishes with the settlers, most notably the Fort Dearborn Massacre, which occurred on August 15, 1812. (Copyright © 1987 by James A. Clifton. Reprinted with permission of Chelsea House Publishers, an imprint of Infobase Publishing, Inc.)

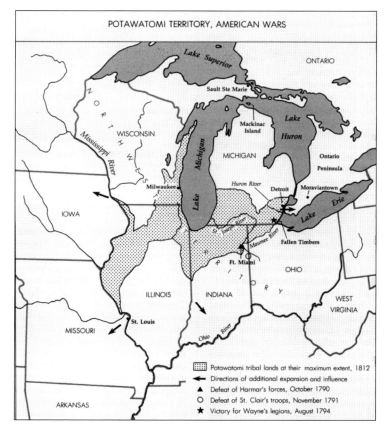

POTAWATOMI TERRITORY, AMERICAN WARS

▦ Potawatomi tribal lands at their maximum extent, 1812
← Directions of additional expansion and influence
▲ Defeat of Harmar's forces, October 1790
O Defeat of St. Clair's troops, November 1791
★ Victory for Wayne's legions, August 1794

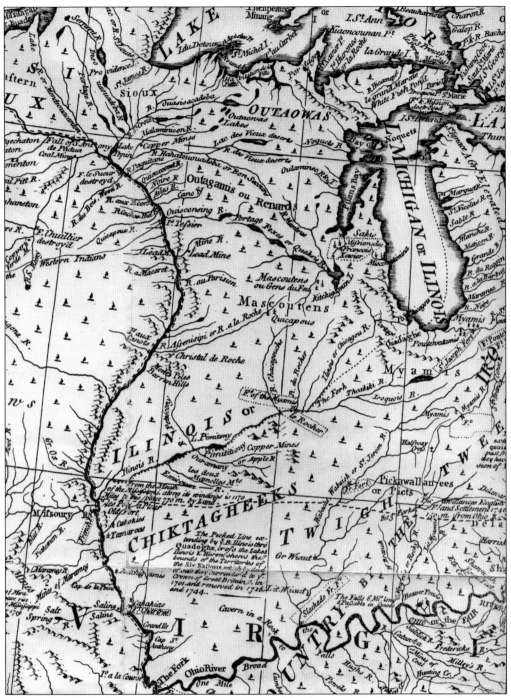

The map depicted illustrates the expansive area covered by the Native Americans in the Northwest territories around 1763 at the end of the French and Indian War. This territory was transferred to the English by the French, pursuant to the Treaty of Paris. Note that at the southern tip of Lake Michigan one will find the territory of the Potawatomi. Their Algonquin cousins, the Mascouten, are a little further to the north and west.

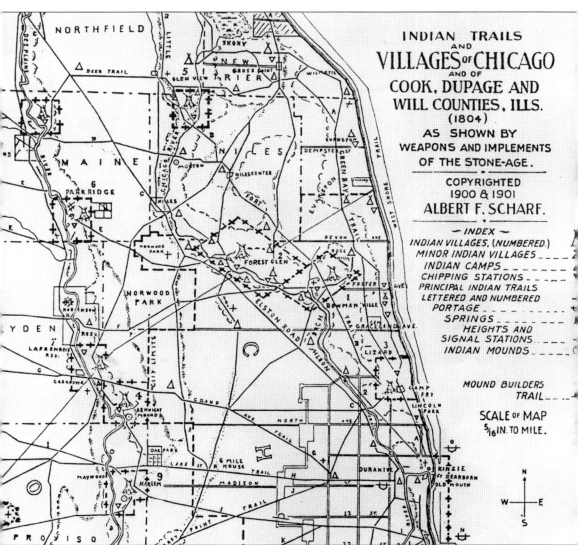

INDIAN TRAILS
AND
VILLAGES OF CHICAGO
AND OF
COOK, DUPAGE AND
WILL COUNTIES, ILLS.
(1804)
AS SHOWN BY
WEAPONS AND IMPLEMENTS
OF THE STONE-AGE.

COPYRIGHTED
1900 & 1901
ALBERT F. SCHARF.

— INDEX —
INDIAN VILLAGES, (NUMBERED.)
MINOR INDIAN VILLAGES
INDIAN CAMPS
CHIPPING STATIONS
PRINCIPAL INDIAN TRAILS
LETTERED AND NUMBERED
PORTAGE
SPRINGS
HEIGHTS AND
SIGNAL STATIONS
INDIAN MOUNDS

MOUND BUILDERS
TRAIL

SCALE OF MAP
5/16 IN. TO MILE.

This map was created by Albert Scharf in 1900. Scharf was a noted historian in Chicago and, according to the Illinois State Historical Library, a student of the local Native Americans. He spent approximately 50 years studying the Potawatomi and their camps, trails, and settlements. In the top third of this map, you can see Niles Center prominently mentioned. Scharf notes a major Native American settlement west of the Chicago River at approximately Old Orchard Road and a minor camp at the intersection of Gross Point Road and Lincoln Avenue shown on this map as "Little Fort Trail."

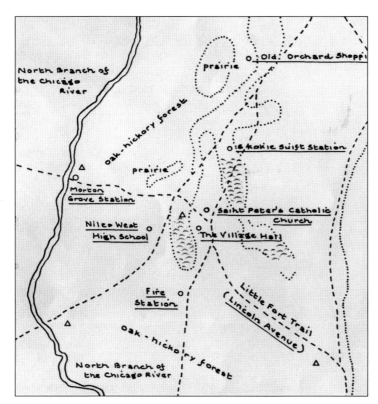

This map was created by David Buisseret and Gerald Danzer and is a composite based on various maps, including the Scharf map from the previous page. Superimposed on the map are present local landmarks, such as Skokie Fire Station No. 16 at 7424 Niles Center Road, the Skokie Swift Station at 5005 Dempster Street, and the Old Orchard Shopping Center on the southwest corner of Skokie Boulevard and Old Orchard Road. Besides indicating Native American trails and camps, the map reflects the area's topography during the Native American presence.

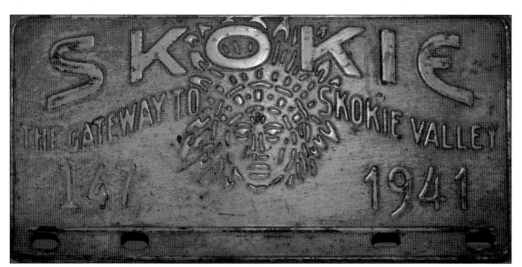

Skokie's Native American past was not only recorded in place names but also in its motor vehicle registration tags. Constructed of metal, this 1941 vehicle tag shows an image of a Native American chief in full headdress. Impressed on the tag is the slogan, "The Gateway to the Skokie Valley."

Shabbona, sometimes spelled Shabonee, was a chieftain of the Ottawa tribe, an Algonquin-speaking tribe closely allied with the Potawatomi. Shabbona, united with the great Shawnee chief Tecumseh, fought against the United States in the War of 1812. Having been defeated by the Americans, Shabbona and Potawatomi chief Sauganash, aka Billy Caldwell, fled to Canada only to make their way back to Illinois. Between 1815 and 1835, Shabbona, recognizing the numerical superiority of the Americans, became their friend, warning them of uprisings and war parties. In 1829, the United States awarded Shabbona a land grant in gratitude for his service during Red Bird's uprising. Shabbona died in 1859. Pictured below, the Skokie Park District has named its park located at 9811 Kedvale Avenue after Shabbona. The park located at 4810 Hull Street is named after the Shawnee chief Tecumseh. (Right, courtesy of the Chicago History Museum, photograph by H. B. Field; Below, courtesy of John Zouras Photography.)

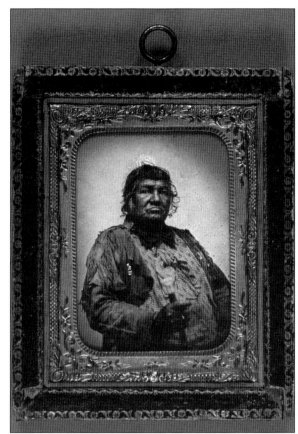

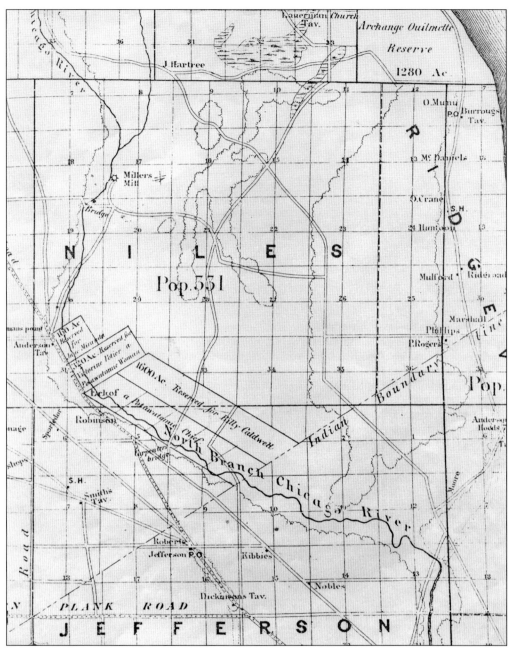

The James H. Rees map shows Niles Township in 1851. In this work, Rees describes the area as a fractional township. The southern portion of the township, along the Chicago River, shows a significant area of 1,600 acres reserved for the Potawatomi chief Sauganash, also known as Billy Caldwell. Sauganash was born near Detroit of a Potawatomi mother and Irish father, served in the British Army, and was educated by the Jesuits. Later on, he was allied with Shabbona and Tecumseh against the Americans in the War of 1812. In the lower half of the map, crossing from left to right is the 1816 Indian Boundary Line, which crosses Niles Township at Devon Avenue just west of McCormick Boulevard. Today part of this plot of land is home to the 18-hole Edgebrook Golf Course owned by the Cook County Forest Preserve.

Two

THE WESTERN EUROPEAN SETTLEMENT
1841 TO 1920

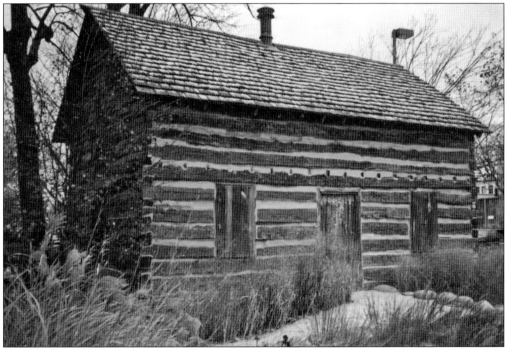

Nicholas and Elisabeth Busch Meyer were among the first permanent nonnative residents in Niles Centre. Nicholas was born in Switzerland, while Elizabeth was born in Alsace-Lorraine. Settling first in Ohio, they traveled to Niles Centre in the 1840s, building the log cabin pictured here in 1847. Meyer made his living as a wheelwright, making wagon wheel spokes, which he sold in Chicago. With the help of his children, Meyer also farmed 60 acres of land. As many as 8 of their 12 children lived with them in the log cabin. Originally located at 5406 Lincoln Avenue, near the intersection of Gross Point Road and Lincoln Avenue, the log cabin was moved to its current location at the Skokie Heritage Museum at 8031 Floral Avenue in 1982. Visitors can tour the log cabin, the oldest structure in Skokie, to understand how pioneer families like the Meyers once lived.

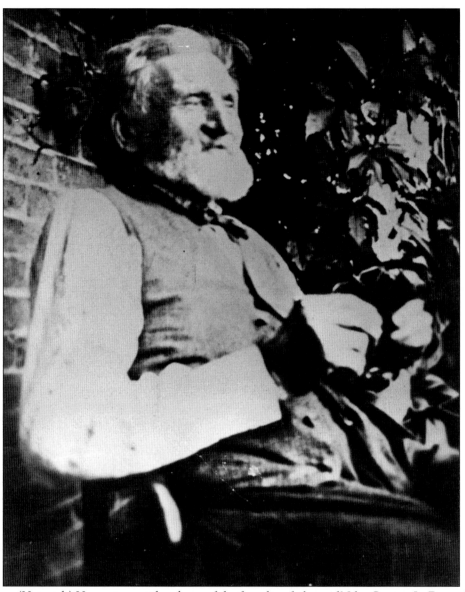

Henry (Heinrich) Harms is considered one of the founding fathers of Niles Centre. In December 1854, Harms migrated from Mecklenburg-Schwerin, Prussia, to Niles Township and settled on land at the intersection of Lincoln Avenue and Oakton Street. In 1855, Harms married Louisa Nicholas with whom he would have 11 children. By 1858, he opened the first store in the area at the southeast corner of Oakton Street and Lincoln Avenue; within a few years, he moved the store to the southwest corner. Harms's building served as general store, tavern, and by 1863, as the first post office. Harms aided the community in draining much of the area's swampy lands to make them suitable for farming, and he rented his land to farmers. Another source of income for Harms was the plank toll road he built from Niles Centre to Chicago along Little Fort Trail, presently known as Lincoln Avenue. He possessed the first telephone in Niles Centre, which was installed in his home in 1886. Harms also held several local offices, including township constable, supervisor and commissioner of highways, and Cook County drainage commissioner. Harms died in 1914.

A successful businessman, Henry Harms once owned much of the land south of Oakton Street, which for some time was referred to as Harms Avenue. Besides establishing the first store on this land, he also built three homes in the area. Harms's financial success is evident by comparing his first home to his third home. The first one, pictured above, was a mere shack located just west of the intersection of Lincoln Avenue and Oakton Street on what is believed to be the present site of Skokie's Village Hall. Harms's third house, pictured below, was built in 1869 at 5319 Oakton Street. Unfortunately this residence was razed in 2002, but it is commemorated in a beautiful oil painting by Eugene Paprocki now displayed in the Skokie Public Library.

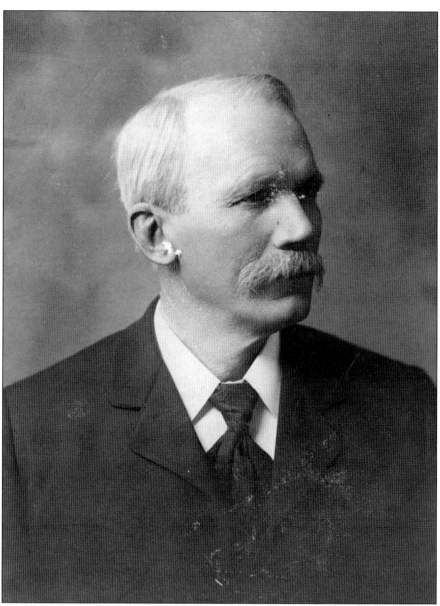

Born in Hesse-Darmstadt, Germany, George C. Klehm arrived in the Jefferson Park area of Chicago in 1855. After earning his teaching certificate, Klehm moved to Niles Centre. While employed as a schoolteacher at Fairview School, he married Henry Harms's sister, Eliza, in 1864. They had 6 children before her premature death. In 1868, Henry Harms sold his store to his brother-in-law. While operating the store, Klehm also held several village and county offices, including village street commissioner, postmaster, village clerk, and for 40 years, Niles Township treasurer. In 1881, he was elected to the Cook County Board of Commissioners. Klehm also owned and operated a picnic grove behind the store and tavern. Considered a bit of a conservationist, it is believed that when trees were cut down to make way for buildings in downtown Niles Centre, Klehm planted new trees in St. Paul Park, which he also owned and operated. St. Paul Park was located in Morton Grove near Ferris and Lincoln Avenues. Klehm eventually donated the land to the Cook County Forest Preserve District. Today it is called St. Paul Woods.

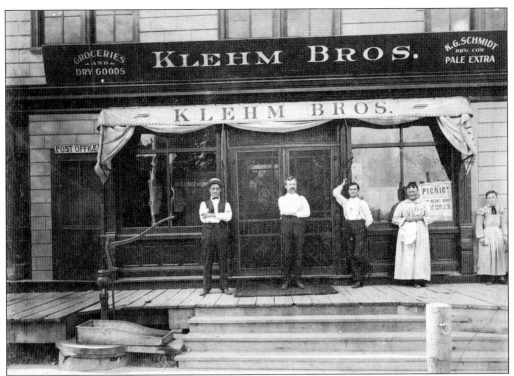

By 1890, George C. Klehm was joined by sons Edwin T. and George H. Klehm in operating the business he had purchased from brother-in-law Henry Harms. The building continued to serve as a general store, tavern, post office, and the first office of George C. Klehm's daughter Dr. A. Louise Klehm. Pictured above, Klehm family members pose in front of the store in 1910 while patrons (below) enjoy a cocktail in Klehm's Tavern. Those seated at the table include, from left to right, two unidentified and ? Pfeiffer. Also pictured are, from left to right, ? Glauner, Bluder Hachmeister, ? Trucker (holding a newspaper), unidentified, Herman Meyer (store clerk), Willie Schaumburg (store clerk), unidentified, Edwin T. Klehm (store owner, also holding a newspaper), Harry "the Painter," Fred Kottke, unidentified, and Henry Klein (farmer).

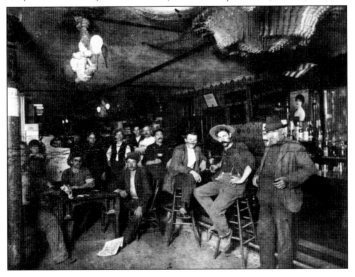

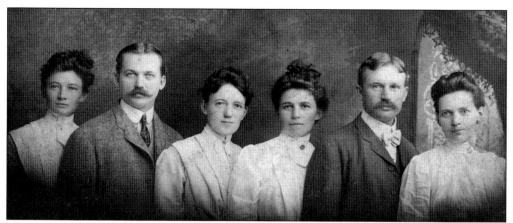

This portrait is of George C. and Eliza Harms Klehm's children. From left to right are Alma Klehm, a school teacher who headed west but later returned to Niles Centre; George H. Klehm, mayor from 1910 to 1922; Dr. A. Louise Klehm, one of the area's first local doctors; Lydia Harms; Edwin T. Klehm, local merchant and postmaster; and Emma Harrer.

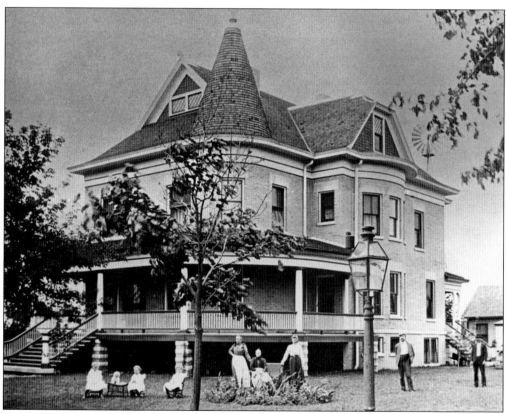

Originally located at 5144 Oakton Street, at the corner of Oakton Street and Floral Avenue, this house was built by Edwin T. Klehm in 1900 and was razed in 1959. It was the first home in Niles Centre to have indoor plumbing powered by a windmill, as well as the first home to have electricity. Several members of the Klehm family pose in front of the residence.

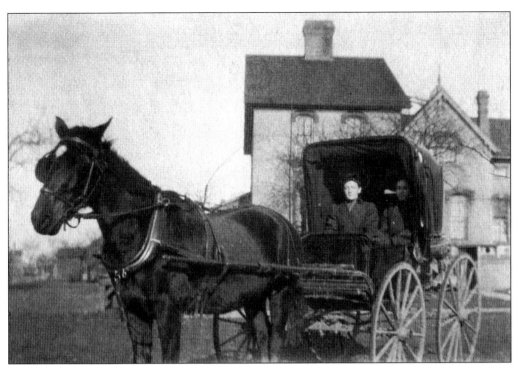

Dr. Klehm served Niles Centre and the surrounding communities until 1936, making house calls in her horse and buggy. She treated ailments and conditions ranging from scarlet fever to childbirth, which was referred to in her ledger as "confinement." The delivery cost $15. During the flu epidemic of 1918, she made 51 calls in one day. Pictured above, Dr. Klehm (at left) is accompanied by her sister Alma. After Dr. Klehm received an extortion letter believed to be from the Black Hand Gang of Chicago demanding that she pay $800 or they would kidnap her brother Edwin's twin daughters, Ruby and Pearl, Alma literally rode shotgun. Dr. Klehm is pictured below with Edwin's children and her father's children with his second wife, Eliza Ruesch Klehm. In front of Dr. Klehm are, from left to right, Edna Ruby Klehm, Irene Klehm, Grace Klehm, Louise Pearl Klehm, and Harold W. Klehm (seated).

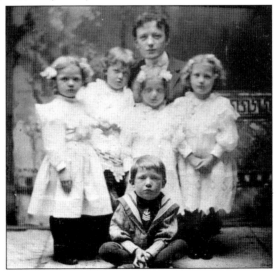

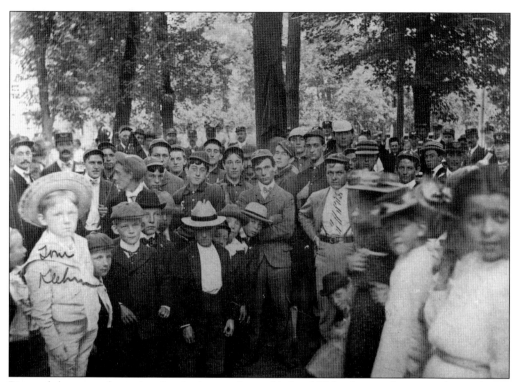

Pictured above, revelers enjoy the picnic grove located behind Klehm's general store on the southwest corner of Lincoln Avenue and Oakton Street, which is pictured below on the left. As indicated on the photograph, this view is looking west down Oakton Street from Lincoln Avenue, originally called Main Street. In 1857, Peter Bergmann arrived in Niles Centre and opened a general store and saloon at the northwest corner of Lincoln Avenue and Oakton Street, but by 1867, he sold this store to Peter Blameuser II, who continued to operate the store and saloon at that location.

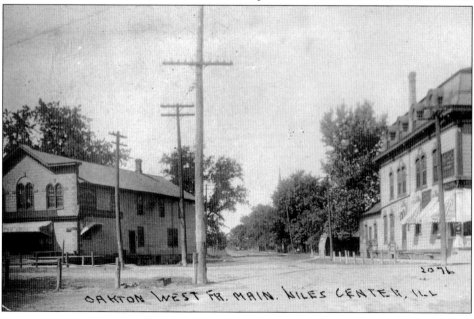

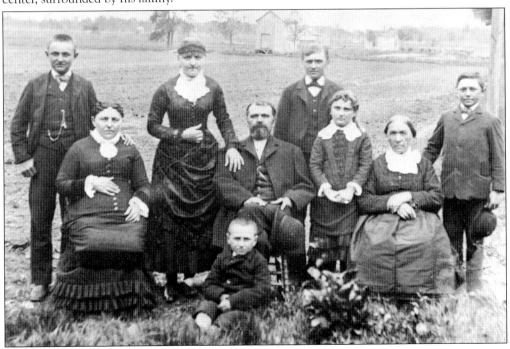

Peter Blameuser

DEALER IN

FLOUR
FEED
WOOD AND
COAL

General Merchandise

CEMENT
TILES
SHAVINGS

WAREHOUSES & YARDS:

NILES CENTRE: C. & N. W. R. R.—MORTON GROVE: C. M. & ST. P. R. R.

'Phone: Morton Grove 221 NILES CENTRE. ILL.

Originally from Prussia, Peter Blameuser II arrived in Niles Centre in 1865. Prior to arriving, he had gone out West to prospect. While there, he joined a vigilante group, although it is not known whether he hanged any outlaws. Blameuser earned approximately $10,000 prospecting and used his fortune to purchase nearly 185 acres in Niles Township, much of which would become downtown Skokie. He owned and operated the general store and tavern, purchased from Peter Bergmann, as can be seen from his business card pictured above. Note the spelling of Niles Centre. He also divided much of the land in Niles Centre into private lots and built and sold many houses on the lots, thus becoming Skokie's first subdivider. Pictured below, Peter Blameuser II is seated at center, surrounded by his family.

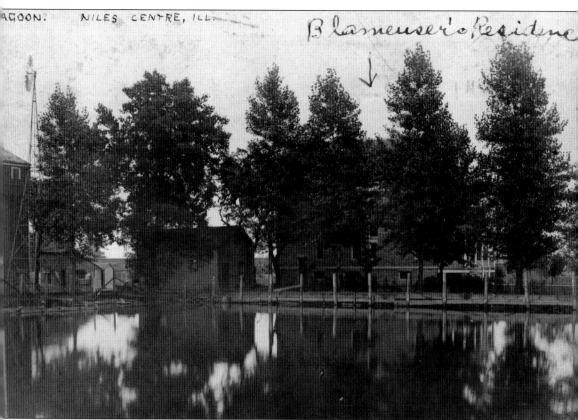

Above is the Blameuser residence and pond, which was located on the northeast corner of Oakton Street and Niles Avenue. The pond was instrumental in saving downtown Niles Center during the fire of 1910, as water was drawn from the pond to douse the flames on Lincoln Avenue. The fire, which destroyed nine buildings in downtown Niles Center, started on a windy and dry September day in the barn behind Jacob Melzer's saloon. Struggling to extinguish the flames with their hand pumper, the Niles Center Volunteer Fire Company was joined by fire companies from Evanston, Chicago, Morton Grove, and Niles. The destruction of property was not the only ill effect of the fire. In order to save their possessions, many property owners placed their items outside on the street. As fate would have it, the fire occurred on market day; hundreds of strangers were in town and looting began. An emergency police force was deputized, which made eight arrests. However, the fire did have its benefits, as the need of a centralized water supply was recognized, and fire resistant brick buildings replaced wooden structures destroyed by the fire.

PETER BLAMEUSER

—❋Wine and Lager Beer Saloon❋—

Anheuser Busch Michelob & Dennehy's Underoo

A SPECIALTY.

NILES CENTRE, (COOK CO.) ILLS

Above is another business card for Peter Blameuser II, indicating one of his many professions—that of saloon keeper. Pictured below, members of the Niles Centre Volunteer Fire Company pose in front of Peter Blameuser's Niles Centre House. The volunteer fire company was formed in 1881 after the bucket brigade, established in 1872, proved ineffective in saving the Iserman family home, then located on the corner of Niles Center Road and Elm Street. The original officers were, seated from left to right, Fred Stielow, vice president; Henry Kolf, secretary; George C. Klehm, president; and Adam Harrer, chief.

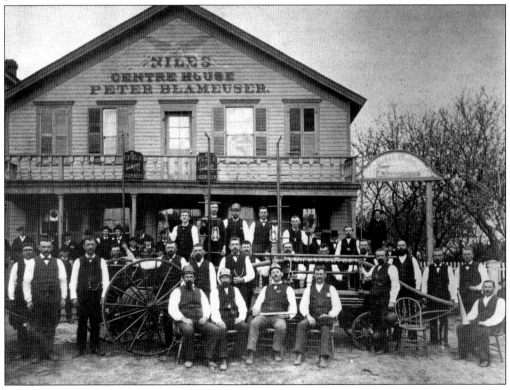

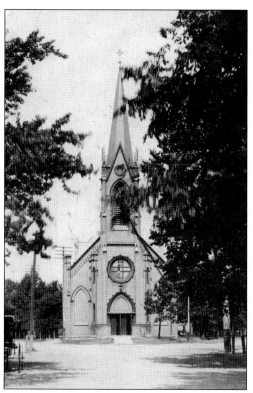

In 1867, Peter and Magdalena Heinz Blameuser donated land for the construction of St. Peter's Evangelical Lutheran Church, below, and St. Peter Catholic Church, at left. Both would be named after Peter Blameuser's patron saint. St. Peter's Evangelical Lutheran Church and school opened in 1868, while St. Peter Catholic Church would conduct its first mass in 1869. A bell tower was added to the original St. Peter's Evangelical Lutheran Church in 1887. However, this tower would be struck by lightning in 1901, damaging the structure to the point that it was rebuilt in 1903. Many items, such as bricks and doorknobs, were reused in the new building. St. Peter Catholic Church's original wooden structure, built at a cost of $3,536, was replaced by the current brick structure in 1894. Designed by Chicago architect Henry Schlacks in Gothic Revival style, it incorporated eight trees into its support system for the vaulted ceiling.

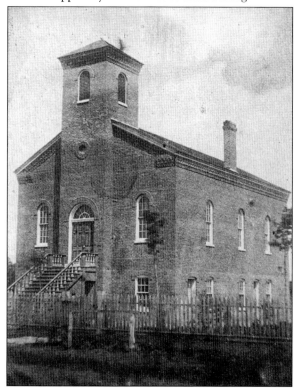

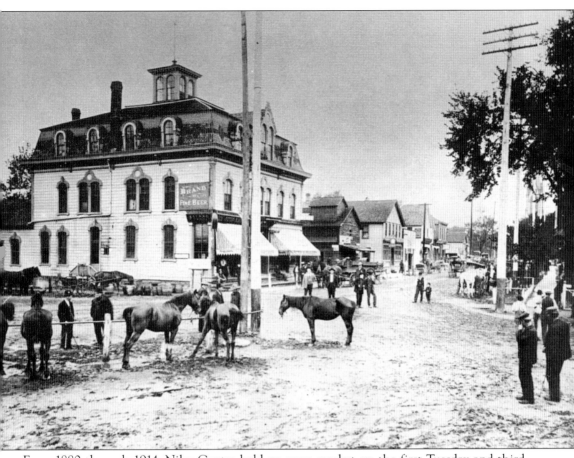

From 1880 through 1914, Niles Centre held an open market on the first Tuesday and third Thursday of each month. Started by Peter Blameuser II and Peter Honvlez, the market stretched north on Lincoln Avenue from Oakton Street to St. Peter Catholic Church and overflowed onto Warren Avenue, then called Market Street. Livestock and other merchandise was bought and traded by farmers and merchants from Chicago and as far away as Kane and McHenry counties. Filled with farmers, merchants, various entertainers and performers, horse races, and packed saloons, Niles Centre was a lively place during market days. This view was taken from the intersection of Oakton Street and Lincoln Avenue. The large three-story building at the left was the Blameuser Building, owned by Peter Blameuser II. Over the years the building housed, among other businesses, a general store, tavern, dance hall, a coffin and furniture store, and the Niles Centre State Bank.

Emigrating from Kaltenbrunn, Bavaria, in 1845, Wolfgang Harrer and his two sons, Michael and Henry, settled on property located on the east prairie near the edge of the forest, near present-day East Prairie Road. After traveling to California to farm, Michael returned to Niles Township in 1855, established a meat market in 1874, and thus became the village's first butcher. Michael Harrer's store still stands at 8051 Lincoln Avenue. Presently it is the home of the John Haben family and is listed on the National Register of Historic Places. Wolfgang's other son, Henry, remained in Niles Township working as a farmer, saloon keeper, store owner, and for 19 years, he served as a justice of the peace. Henry's sons, George and Adam, were also civic-minded, becoming the first mayors of Morton Grove and Niles Centre respectively. Adam Harrer, pictured here, was not only Niles Centre's first mayor, but was also the first fire chief. His home is pictured below. (Bottom photograph courtesy of John Zouras Photography.)

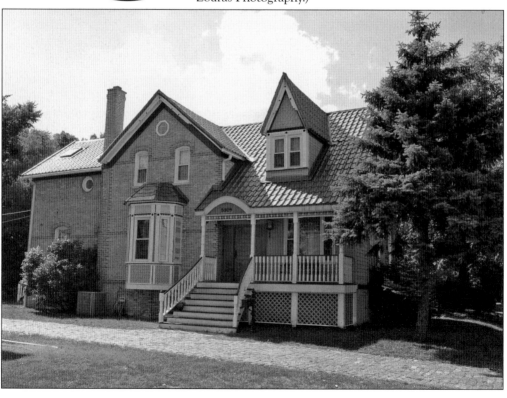

Built in 1887, the Engine House at 8031 Floral Avenue was Niles Centre's first public building and, therefore, served many purposes in the community. It was a working engine house until 1969 and housed two jail cells from 1888 until 1927, when the current village hall was built. It also served as a dance hall and meeting hall. In 1888, the vote to incorporate Niles Centre occurred within its walls. After 1969, it served as home to the village health department and then, in 1982, home to the Skokie Historical Society. In 1992, relying on photographs similar to the one at right, it was restored to its 1900s appearance. It is now the Skokie Heritage Museum and continues to be home to the Skokie Historical Society. Pictured below, uniformed members of the Niles Centre Volunteer Fire Company pose in front of the Engine House, joined by the Niles Centre police constable, standing to the far left.

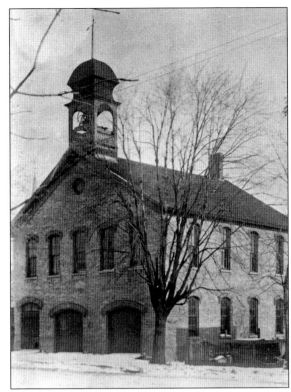

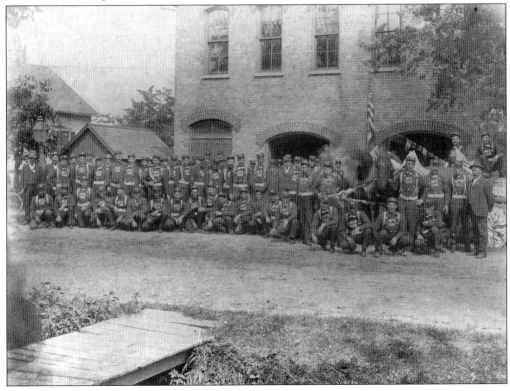

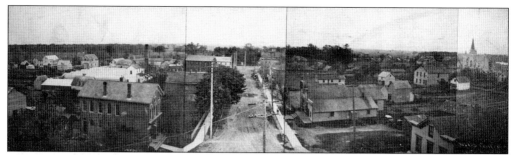

Rev. Bernard Schuette, pastor from 1892 to 1907, took this panoramic view from the steeple of St. Peter Catholic Church. The view stretches east to Niles Avenue, south along Lincoln Avenue, and west to Laramie Avenue. Some buildings visible are the Harrer Meat Market to the east, the Blameuser Building to the south, and St. Peter's Evangelical Lutheran Church and the Engine House to the west.

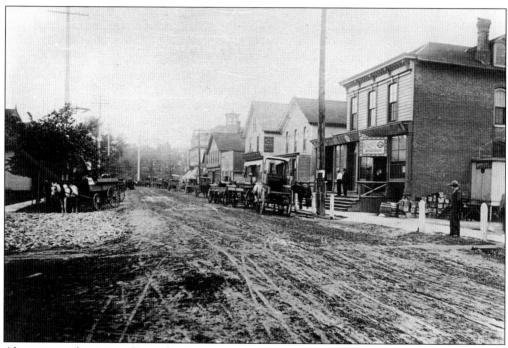

Above is another view of Lincoln Avenue from the early 1900s. This view was taken from street level, looking south from Warren Street towards Oakton Street. As Lincoln Avenue, between Oakton Street and St. Peter Catholic Church, was the main street in the village, many local businesses were located there. Most of these local businesses pictured above were destroyed in the large fire that raged in September 1910.

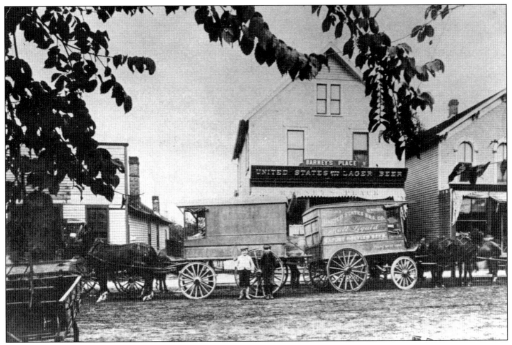

Young boys pose with beer wagons in front of storefronts on Lincoln Avenue. The businesses pictured are Ludwig Luebbers Horseshoeing at 8018 Lincoln Avenue, Barney Connelly's Tavern at 8020 Lincoln Avenue, and Siegel's Cigar Shop at 8022 Lincoln Avenue. The 8018 and 8020 Lincoln Avenue wooden structures were destroyed in the September 1910 fire.

Trudging through snow, a delivery is made by sled to one of Niles Center's many taverns, then located on Lincoln Avenue. Owned by Lorenz Schaub, the tavern shown here was located at 7923 Lincoln Avenue, which was further south than the businesses pictured at the top of the page.

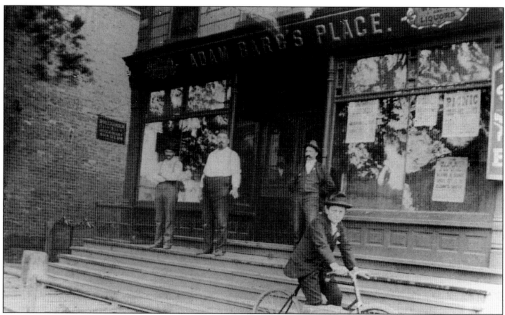

Taverns in Niles Centre were plentiful. It was said that Niles Centre purchased Evanston's water and Evanston bought Niles Centre's booze. Here are two more taverns on Lincoln Avenue. One was run by Adam Barg, above, and the other by Anton "Tony" Seul, below. Pictured above, Adam Barg stands in the center wearing a fez in front of his thirst emporium, which was located at the northeast corner of Lincoln Avenue and Warren Street. Adam Barg was active in the German club, Platt Dutsche Gilde, while Anton Seul was a member of the Luxembourg Brotherhood of America. Visible below at the far left, behind the bar, Seul is pictured holding his son inside his tavern. Seul's tavern was located at 8000 Lincoln Avenue. During the Roaring Twenties, when alcohol was illegal to possess, Niles Center's many taverns went underground and became speakeasies. Harms's last home was used as a distillery for cheap (and illegal) wine during the 1920s.

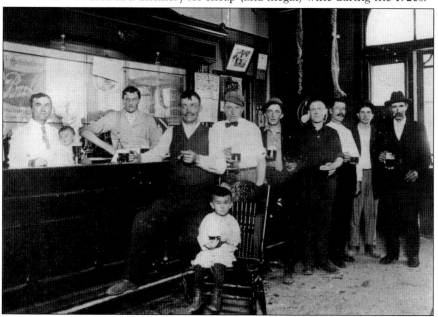

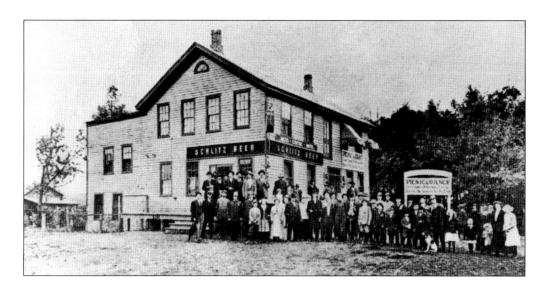

Above is the Niles Centre Hotel, built by Henry Harms in 1858 on the southeast corner of Lincoln Avenue and Oakton Street along with his general store and tavern. Subsequently, Fritz Rose, a future village trustee, operated it. The hotel stood until 1911 when it was destroyed by fire. During the Depression, the site was developed into a service station and is presently Krier Plaza. Fritz Rose and his spouse are pictured below with guests inside the hotel. Mrs. Rose is seated second from the left and Fritz Rose is standing fourth from the left. The village constable, Andrew Schmitz, is identified as standing to Fritz Rose's right.

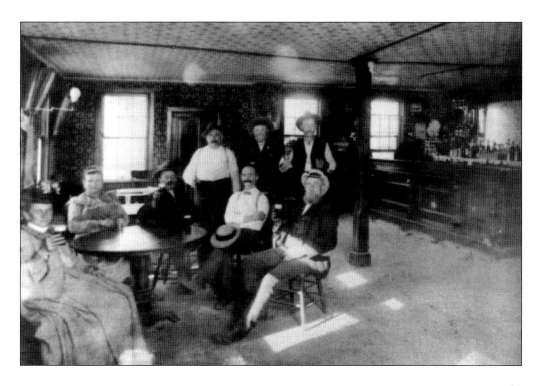

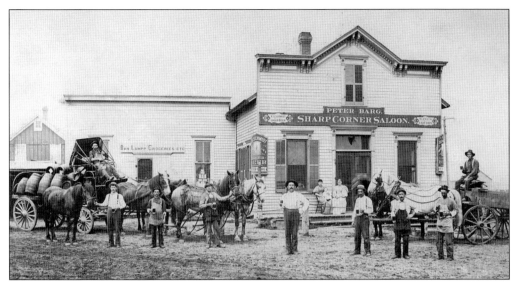

Until its annexation by Niles Center in 1924, Sharp Corner was its own community. Located north of Church Street and east of Skokie Boulevard, Sharp Corner had its own fire department and several taverns. Pictured above, Barg family members and patrons pose with beer steins in hand and full wagons in front of Peter Barg Sharp Corner Saloon and Dan Lumpp Groceries. Also in Sharp Corner, the Farmers Exchange is pictured below with staff, patrons, and children posing with beer in hand in 1910. The owner was believed to be a Mr. Krizanetz, who was known as "Chicken Fritz." The tavern changed hands, becoming the 19th Tee, operated by Luxembourger Peter Hohs, pictured at the center of the photograph with arms crossed. On the far left is "Handsome" John Kalmes, whose grandson currently operates Marge's Flowers at 8038 Lincoln Avenue.

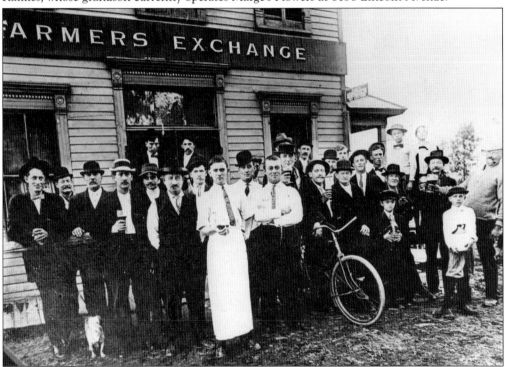

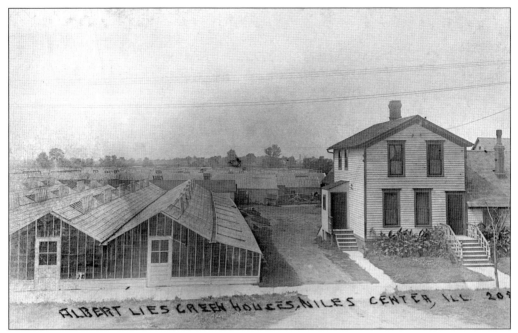

ALBERT LIES GREEN HOUSES, NILES CENTER, ILL. 20?

Farming and greenhouses were a common source of income for Niles Center's German and Luxembourgian immigrants. Pictured here are two greenhouses owned by Luxembourgers. Above are the home and greenhouses of Albert Lies located at the northwest corner of Floral Avenue and Cleveland Street, which were replaced in the 1920s by the Niles Center Recreation Rooms. Below are the home, greenhouse, and fields owned by Michael and Ernestine Hermes, who pose with family in front of and atop the greenhouse c. 1907. The Hermes homestead was located at 9901 Gross Point Road in Sharp Corner on what is now the northern section of Skokie, north of Memorial Park Cemetery.

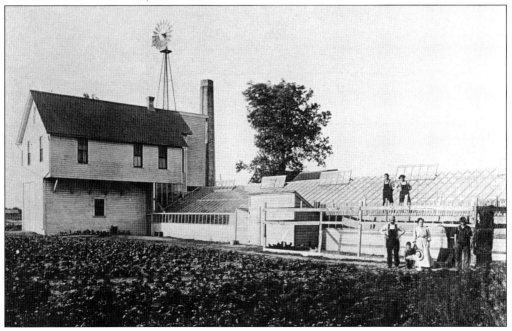

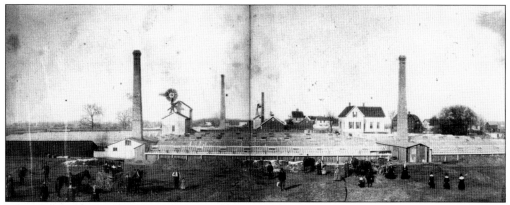

The Lies greenhouses were not the only greenhouses on Floral Avenue. Next to them were those owned by German immigrant Frederick Stielow. Stielow and partner Kusky started the first greenhouse in Niles Centre in 1874. After Kusky accidently shot himself, Stielow partnered first with Kusky's widow and then with Albert Lies. Later, without a partner, Stielow ran one of the largest greenhouse operations in the area. The panoramic view above is of the Stielow and Lies greenhouses on Floral Avenue.

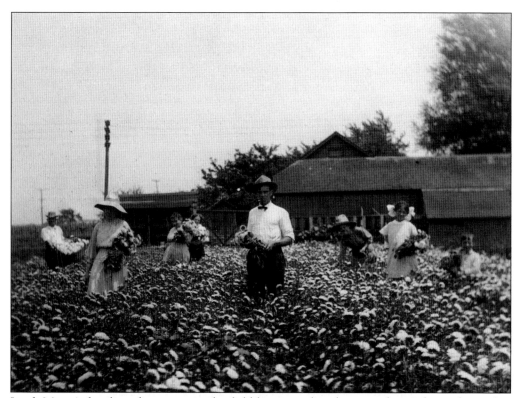

Jacob Meyer's family gathers aster in the field between their home and greenhouse located at 5406 Lincoln Avenue near the intersection of Gross Point Road. George Meyer is identified as standing at the center. Also seen in the distance, behind and above the barn, is the Meyer family log cabin. Although the Meyers eventually built a larger house at East Prairie Road and Greenleaf Street, Jacob and his wife, Margaret, returned to the cabin to start their family.

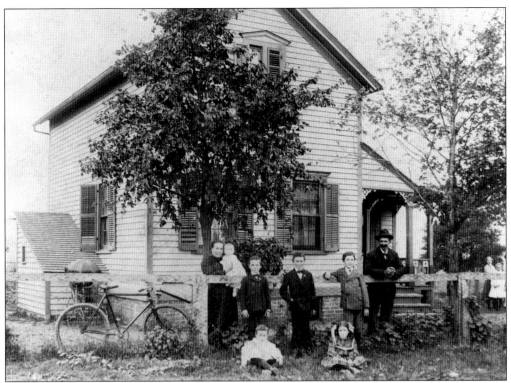

The Dahm family owned and operated farmland and greenhouses near Dempster Street and Gross Point Road. Pictured above, Nicholas Dahm and his family pose in front of their home, which was located on what is now Lockwood Park. Behind their home, they planted 5 acres in buttercups and blueberries. Pictured are, from left to right, a pregnant Margaret Baumhardt Dahm holding Bernard, Raymond, Nicholas (seated), George, Mathilda (seated), Philip, and Nicholas Dahm. Pictured below, Nicholas's cousin Peter poses with family in their greenhouse. An owl is perched on the pipes to the right to serve as protection from pests. By 1924, the land, then owned by Peter Dahm and his wife, Wilhelmina Fortmann Dahm, and situated between Dempster Street, Gross Point Road, and the Chicago Northwestern Railway, had been subdivided.

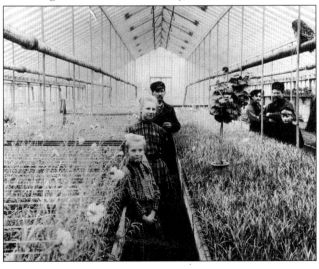

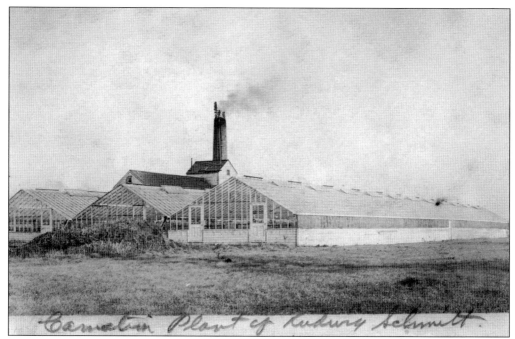

Carnation Plant of Ludwig Schmitt.

Besides produce, many Niles Centre farmers and greenhouse operators also grew flowers, which were often sold to wholesalers and hotels in Chicago. Some Niles Centre flower growers were Herbert Baumann, Emil H. Blameuser, John C. Meier, Ludwig Schmitt, and the Stielow Brothers. Pictured here are the exterior and interior of Ludwig Schmitt's carnation plant. Pictured below, Charles August Schmitt gathers carnations inside one of the greenhouses. Still present through the mid-1960s, most greenhouses in Skokie were gradually eliminated because of the pollution caused by smoke from the greenhouse chimneys. One such chimney can be seen above at the center of Ludwig Schmitt's plant. In addition, the value of the land for redevelopment purposes exceeded the value of the land when used for an operating greenhouse.

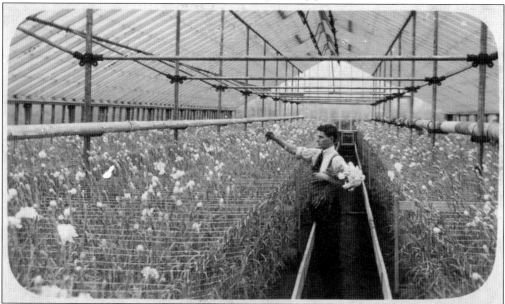

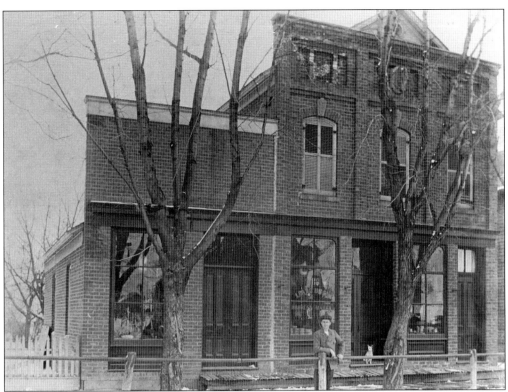

Since horses were the main means of transportation in early Niles Centre, wagon makers, blacksmiths, harness makers, and horseshoers were abundant and integral to everyday life. Traveling from Bohemia, Ivan Paroubek arrived in Niles Centre in 1869 and established a harness shop, shown above, at 8045 Lincoln Avenue, just south of the present-day Haben Funeral Home. The purpose of the store was reflected in its facade; a decorative horse is clearly visible in the top center of the building. An unidentified son of Ivan Paroubek is pictured with a dog in front of the shop. Pictured below, workers pose in front of Lohrke Brothers Horseshoeing and Wagon Manufacturing, which was located on Niles Center Road just north of St. Peter Catholic School. The worker on the right is seen shoeing a horse.

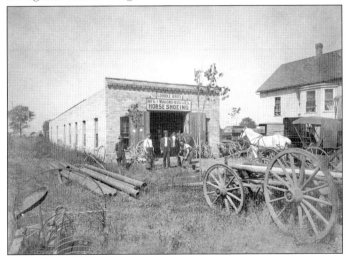

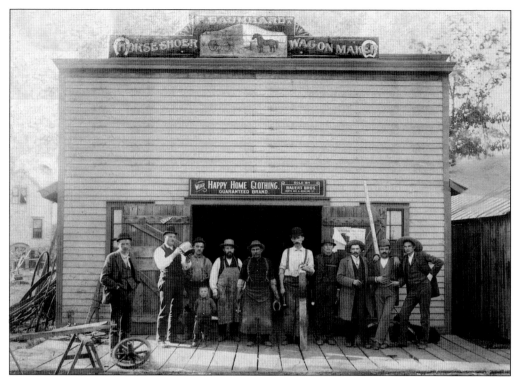

Opened around 1885, P. Baumhardt's Horseshoer and Wagonmaker business was located at 7902 Lincoln Avenue, on the corner of Lincoln Avenue and Galitz Street. The business was later purchased by Fred Schoening, who eventually moved it to 7880 Lincoln Avenue, where he built a brick building to replace the wooden structure pictured above. A remnant of Schoening's shop at 7880 Lincoln Avenue is still visible today; a horseshoe is embedded in the sidewalk in front of this location. Schoening worked on many residents' wagons and buggies, including that of Dr. A. Louise Klehm. Ludwig Luebbers also operated a horseshoeing, blacksmithing, and wagonmaking shop in downtown Niles Centre, as can be seen from his business card below. Luebbers' shop was located next to Schmitz's Tavern at 8018 Lincoln Avenue. Some of Luebbers's customers included Robert Siegel and Michael Harrer.

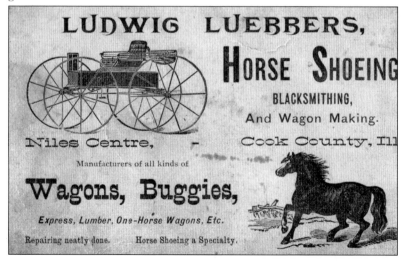

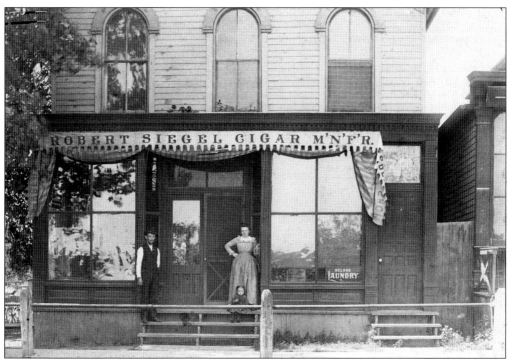

Cigar manufacturer August Siegel arrived in Niles Centre in 1874 and opened a cigar store. Siegel, who lived across from the Engine House, was also the town bandleader and a member of the Niles Centre Volunteer Fire Company. Before the bell tower was added to the Engine House, Siegel would blow his bugle to summon volunteer firefighters. Pictured above in front of the cigar store started by August Siegel are, from left to right, Robert Siegel, a barber who took over the store from his father; Ma Siegel; and Frances Siegel. Also a member of the volunteer fire company, serving as chief pipe man, was Medard Gabel, who opened the village's first hardware store in 1883. Below, Medard Gabel poses with family and their dog in front of his hardware store. Although the porch has since been removed, this brick building is still located at 8122 Lincoln Avenue.

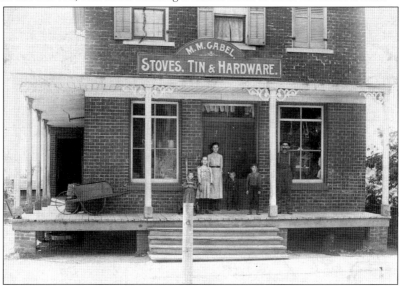

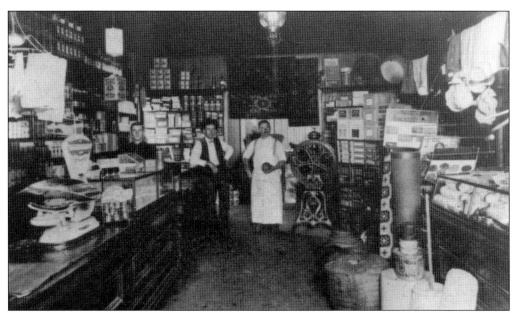

This photograph is an interior view of Schoeneberger's General Store, which was located at 8042 Lincoln Avenue. The wood frame store pictured was replaced by the stone structure that is still standing. This building continued to serve as Schoeneberger's General Store until replaced by Paroubek's Bakery around 1945. Those pictured include, from left to right, John Schoeneberger, Edward Schoeneberger (leaning on counter), and butcher ? Franz.

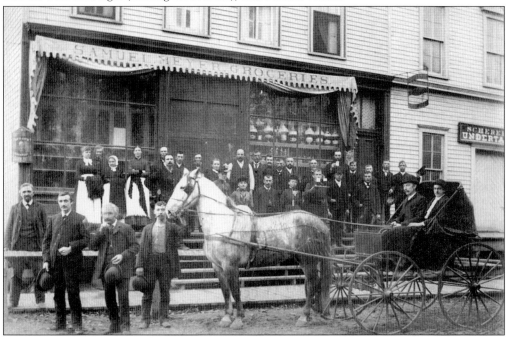

Villagers pose in front of the grocery store owned and operated by Samuel Meyer, son of Nicholas and Elizabeth Meyer. It was located on the west side of the 7900 block of Lincoln Avenue, just south of the Niles Center Theater, which was also owned and operated by Samuel Meyer. At the far right, one of Niles Centre's early mortuaries, Scherer's Undertaker, is next to the grocery building.

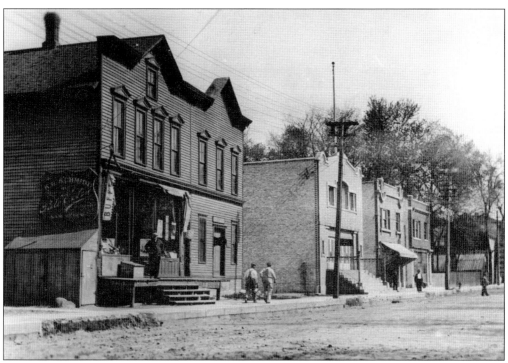

This view of Lincoln Avenue, looking north from Galitz Street, was taken around 1916. The Niles Center Theater was built in 1915, and cement sidewalks were poured at that time. Pictured on the left is Samuel Meyer's grocery store, and to its right is the Niles Center Theater with its original front steps visible. Meyer's grocery store building was still in existence into the 1970s and housed Raymond's Work-N-Sport.

This snow-covered view is looking west along Galitz Street from Lincoln Avenue. The homes located here were among the earliest in the village and were made of white clapboard, as pictured on the left and right. Clapboard was a common type of siding for wood frame houses. These homes were still present into the early 1970s, until they were razed and replaced by condominium buildings. In the foreground, a child, identified as a member of the Poppenhagen family, sits on a sled.

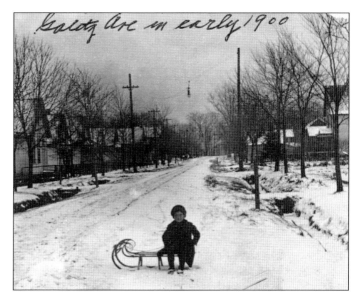

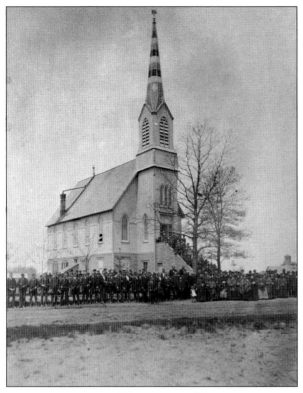

Founded by a group of dissident congregants from St. Peter's Evangelical Lutheran Church, St. Paul Evangelical Lutheran Church and school opened at the southwest corner of Galitz Street and Lincoln Avenue in 1881. By 1910, the church's original wooden structure was replaced by the current brick building. As most congregants were of German descent, some services continued to be conducted in German until the 1950s. The church and congregation are pictured at left, while students at St. Paul School in 1915 are pictured below. During its first three years, the school averaged an attendance of 80 pupils. Now called St. Paul Lutheran Academy, the school is still open but was closed during the Great Depression and reopened in 1954 in its current building.

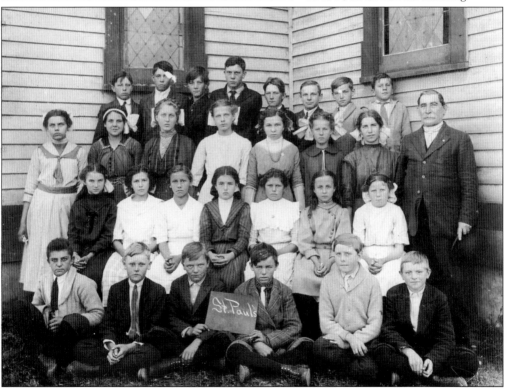

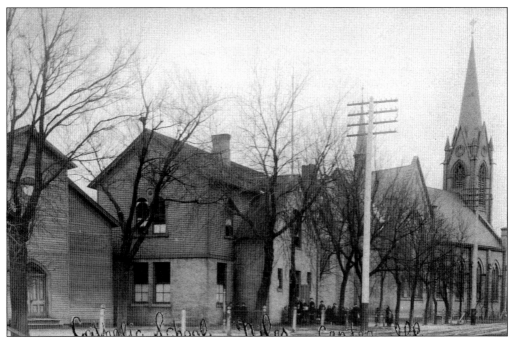

St. Peter Catholic School was built in 1873 at the "V" where Lincoln Avenue and Niles Center Road meet but moved north 20 years later to make way for the current church building. The school on Lincoln Avenue is pictured above. To the left of the school is the original wooden church structure. Pictured below, female students participating in a pageant pose with clergy. Margaret Witty is identified as being in the fourth row, third from the left, wearing the chef's cap. St. Peter Catholic School, which is still open, built a new, 10-room school building in 1928 to accommodate its growing enrollment, which reached 243 students in that year.

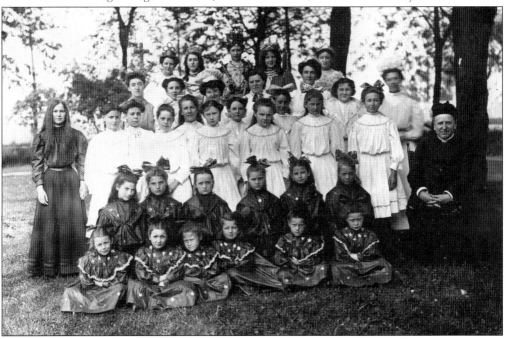

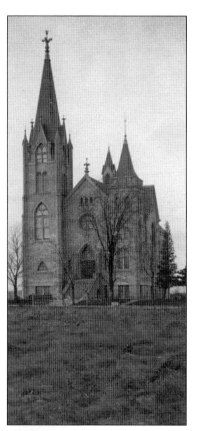

St. Peter's Evangelical Lutheran Church's original building, constructed in 1868, was replaced in 1903 by the current structure pictured here. Like its predecessor, this building also experienced a bit of bad luck. In 1913, the bell tower's corner turrets were torn off by a violent storm. In 1957, this evangelical church merged with the Congregational Christian church. As a result of the merger, the church was renamed St. Peter's United Church of Christ.

St. Peter's Evangelical Lutheran Church students pose in costume for a play. Pictured here are, from left to right, (first row) Ruby Klehm Harms, Mabel Ruesch Holtman, Harold W. Klehm, two unidentified, and Pearl Klehm Mayer; (second row) Laura Jarmuth Heibe, two unidentified, and Minnie Jarmuth Reinberg; (third row) Otto Mayer, two unidentified, Raymond C. Klehm, two unidentified, and Irene Klehm Harms.

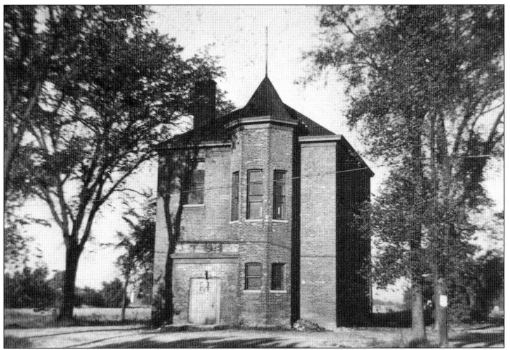

Opened in 1858, Fairview School was the first school in Niles Centre. The school building pictured above replaced the original one-story schoolhouse built at the corner of Howard Street and Niles Center Road. Pictured below, Fairview School primary class students, teacher, and principal pose in front of the school building. The following are identified in the photograph: Alma Klehm, the principal, is seated at the far left in the third row, and Kathryn Woodward, the teacher, is standing at the far right in the third row. Alma Klehm began her teaching career around 1900. She was a prominent fixture in Skokie until her death in 1974 at age 98. In 1962, she was the cover girl for the First National Bank of Skokie's calendar.

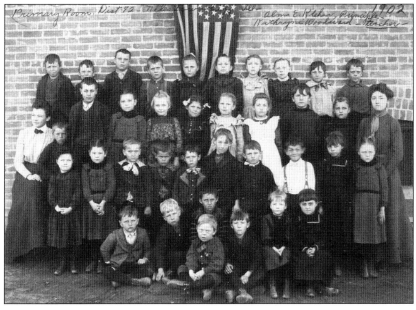

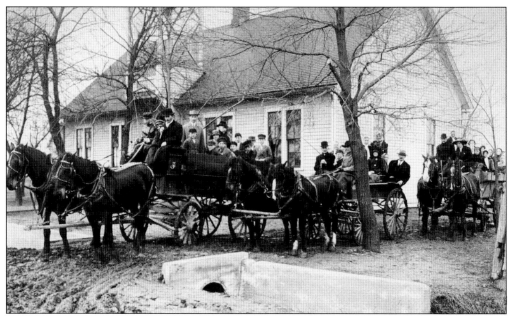

In 1895, the Harrer family donated land for East Prairie School at the corner of Howard Street and East Prairie Road. According to a history of East Prairie School by Frank Bicknase, the teachers were originally paid 130 silver dollars each month, as their pay came from local taxes, which were collected in silver dollars. Several wagonloads of students and parents pose in front of the two-room schoolhouse around 1900.

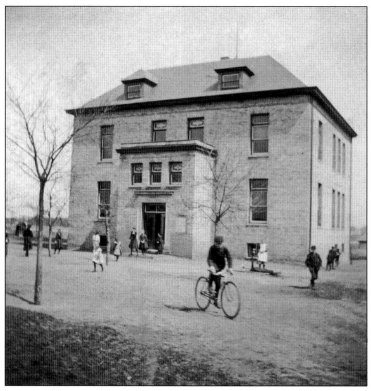

Located on Madison Street east of Niles Center Road, where the main post office currently operates, the Niles Centre Public School was built around 1898. During construction, the second floor of the Engine House at 8031 Floral Avenue served as the schoolhouse. By 1930, the school had been replaced by a new school at 7839 Lincoln Avenue called Lincoln School, later to become Lincoln Junior High.

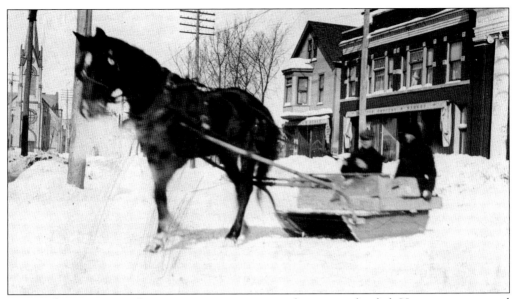

During the winter months, an easy way to get around town was by sled. Here two men travel through downtown Niles Center on a horse-drawn sled. Visible in the background are St. Peter Catholic Church, the Niles Center State Bank, and the Niles Center Grocery and Market owned by the Busscher family, whose grand nephew, William Schmidt, is currently the superintendent of business services at the Skokie Park District.

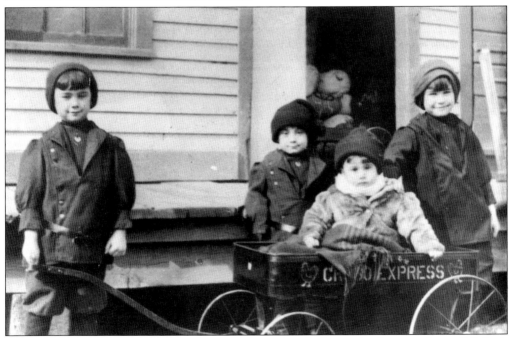

The sons of Anton Seul, bundled up for a cold day and ready for mischief, pose in front of Klehm's Store on Lincoln Avenue around 1918. The boys identified are, from left to right, Francis "Pat" Seul, Rudolph "Buddy" Seul, Irwin "Mupps" Seul in the wagon, and "Bingo" Seul. Pat Seul, like his father, joined the Skokie Fire Department and became a lieutenant in the fire prevention bureau. See a grown-up Pat Seul on page 95.

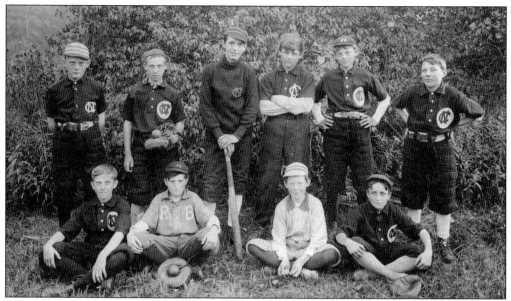

Pictured are members of the 1910 Niles Center Athletic Club. Those pictured are, from left to right, (first row) John Busscher, George Schmidt, Harold W. Klehm, and Albert "Buddy" Bauman; (second row) Master Hackmeister, Walter Baumann, George "Lordy" Remke, Master Rose, Waldo Brown, and Walter Baumhardt. Mayor George H. Klehm founded the club.

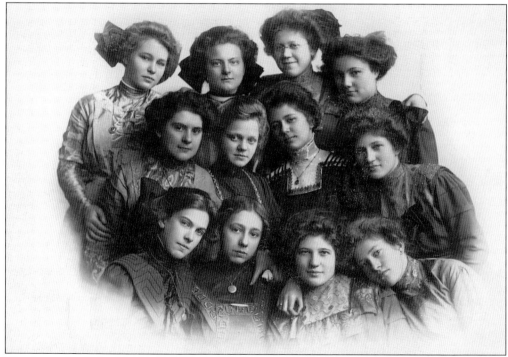

The Junior Bachelor Maidens Club was organized in 1910. Members pictured around 1916 are, from left to right, (first row) treasurer Jessy Gay, Gertrude Kindt, president Ruby Klehm, and vice president Minnie Jarmuth; (second row) Jeanette Proesel, Grace Klehm, Ruth Fromhold, and Pearl Klehm; (third row) Mabel Ruesch, secretary Evelyn Brown, Irene Klehm, and Myrtle Harms.

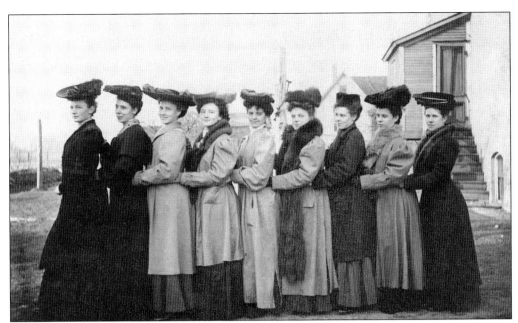

Members of the Bachelor Maidens of Niles Centre pose for a photograph around 1900. This group arranged socials and sponsored a dance each year. Those pictured include, from left to right, Alma Klehm, Louise Stielow, Emma Kruse Wolters, Lucille Harrer Little, Ann Schmitt, Florence Klehm Freund, Elsie Stielow, Mae Stielow, and Elizabeth Stielow.

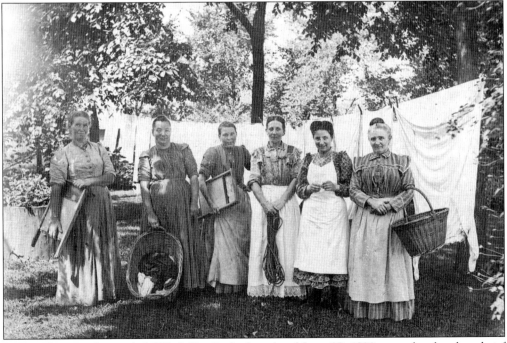

In this photograph entitled "Wash Day," which is dated June 30, 1899, some locals take a brief break from laundering. Those pictured are, from left to right, Ma Weis, Lizzie Harrer, Mary Baumhardt, Ma Reem, Julia Meyer Gaynor (daughter of Julia and Samuel Meyer), and Julia Meyer (wife of Samuel Meyer).

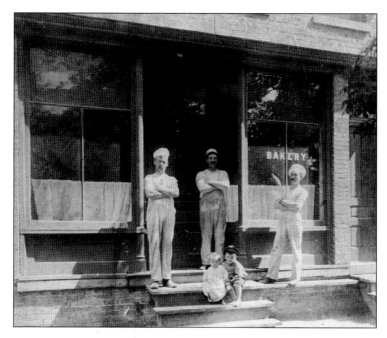

Workers take a break and pose with children in front of Paroubek's Bakery, located at 8101 Niles Center Road. The bakery opened around 1915. It later moved to 8044 Lincoln Avenue and was renamed Paroubek's Community Bakery. Even though Paroubek's Community Bakery has since closed, the space has remained in use as a bakery—first as Vitello's Bakery and currently as Sweety Pie's Bakery.

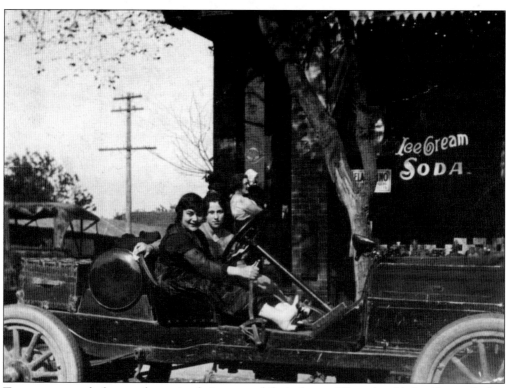

Two women ready for travel pose in their automobile in front of Baumhardt's Ice Cream Parlor. The shop was located at 8023 Lincoln Avenue on the southeast corner of Lincoln Avenue and Warren Street. In the background, Gertrude Baumhardt, gazing off to the right, holds Harold Baumhardt.

Pictured at right is the first building occupied by the Niles Center Mercantile Company around 1907. The location of this building remains a mystery. The business was run by a partnership consisting of George Busscher Jr., Ray Haben, and Herman Grosse Sr. Eventually Haben and Grosse were bought out and the Busscher family ran the operation. Pictured below is its second location. Note that the business sold paints, hardware, Studebaker automobiles, wagons, harnesses, and buggies, a sample of which can be seen in the second floor show window on the right. Eventually, in 1928, the business signed on with the Ace Hardware cooperative and became store number nine in that chain.

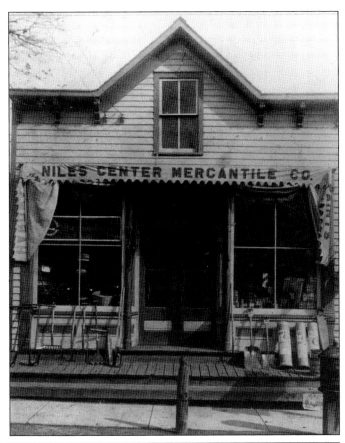

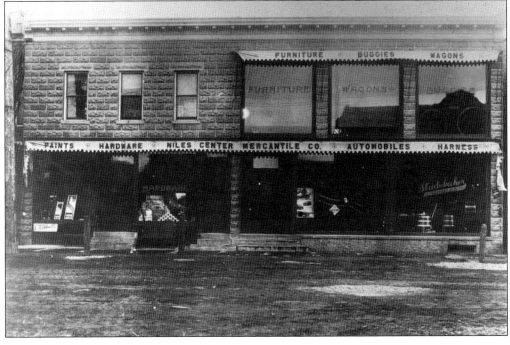

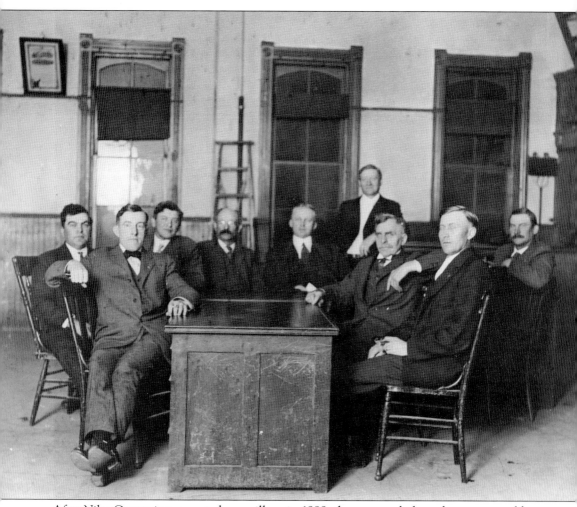

After Niles Centre incorporated as a village in 1888, the mayor, clerk, and trustees would meet on the second floor of the Engine House at 8031 Floral Avenue. Village proceedings continued at that site until relocating to the current village hall in 1927. The village board pictured here at the Engine House around 1918 are, from left to right, Christ Blameuser, trustee; Robert Hoffman, trustee; Albert Lies, trustee; Samuel Meyer, trustee; George H. Klehm, mayor; John W. Brown Sr., trustee; Richard Kruse, trustee; and Charles Langfeld, village clerk. An unidentified consultant is standing in the rear. This photograph was one of several relied upon by architect Will Hasbrouck when restoring the Engine House in 1991 and 1992.

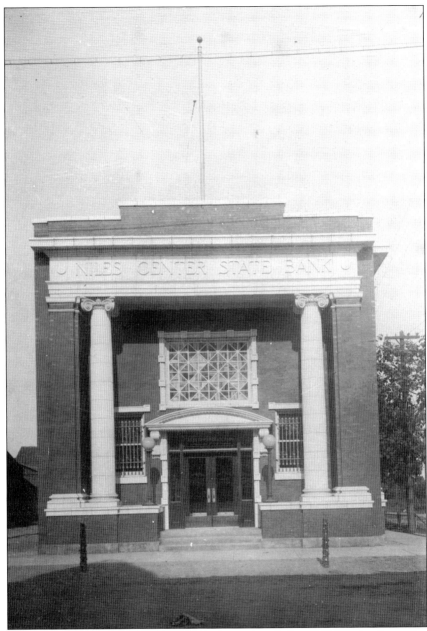

Pictured here is the Niles Center State Bank, which was founded in 1907. The bank was first located across the street in the Blameuser building next to the Seul Tavern. In 1916, bank management, under the guidance of Peter Hoffman and William Galitz, constructed this two-story building at 8001 Lincoln Avenue. Over the course of many years, the bank purchased several adjoining properties to house its operations. In 1946, the Niles Center State Bank became the First National Bank of Skokie. At this time, Willard C. Galitz, William's son, was chairman. The bank operated from this building and its several add-ons until 1973 when the present edifice was constructed. It is now a Chase Bank branch. The founders of the bank were attorneys Charles Castle and Arista B. Williams of the law firm Castle, Williams, Long, and Castle; William Galitz; Peter Hoffman; and John W. Brown.

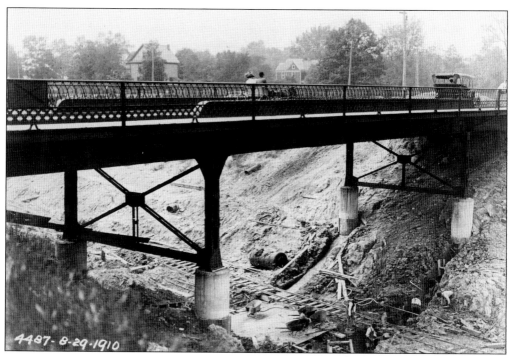

4487-8-29-1910

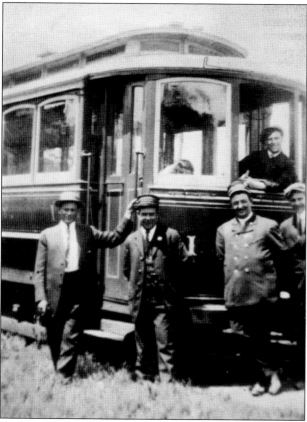

In the 1890s, the Metropolitan Sanitary District, originally the Chicago Sanitary District, reversed the flow of the Chicago River and constructed a sanitary and ship canal in order to divert pollution from Lake Michigan. By 1908, it was necessary to divert more water from the lake, so the North Shore Channel was built. Here workers toil to complete a section of the channel that runs from Lake Michigan in Wilmette along McCormick Boulevard to the Chicago River at Lawrence Avenue.

From 1907 to 1933, the North Shore and Western Railroad trolley line ran from Central Avenue and Lincolnwood Drive in Evanston to the Glen View Golf Club along Harrison Street, now Old Orchard Road. Its crew poses here in front of car no. 1, named the "Dinky," which was the source of the line's nicknames of "Hinky Dink" or "Dinky Line."

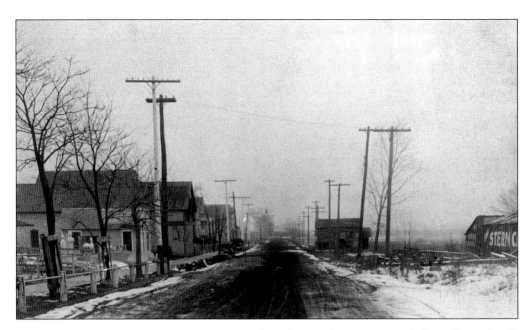

Even though the first mile of permanent paved road in Cook County was dedicated on Church Street in Niles Center in December 1913, these images of downtown Niles Center with dirt roads were taken later, as evidenced by the dominant presence of telephone lines, paved sidewalks and the Niles Center State Bank, which was built in 1916. Pictured above, looking east down Oakton Street from Lincoln Avenue, very few homes and businesses are visible, except for a tombstone and monument business to the left. Below is a view of Lincoln Avenue looking north from Oakton Street. Buildings visible in this photograph are, from left to right, the Blameuser Building, St. Peter Catholic Church, Niles Center Grocery, and Niles Center State Bank.

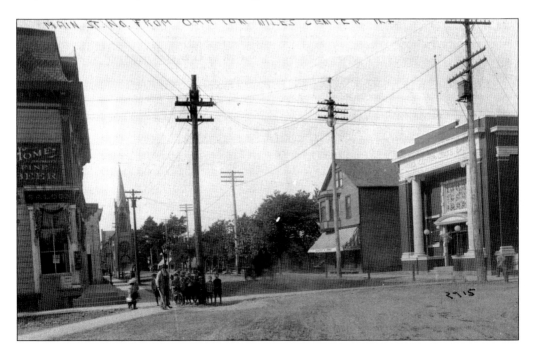

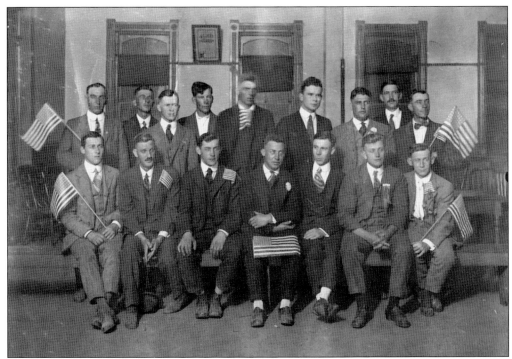

The Great War, also known as World War I, did not leave rural Niles Center untouched. Uncle Sam's tentacles reached near and far, and in 1917, this group of Niles Center volunteers headed off to Camp Grant located in Rockford, Illinois. Pictured are, from left to right, (first row) three unidentified, Penny Baumann, ? Stielow, unidentified, and ? Bucknerhauer; (second row) Joe Weiss, unidentified, Howard Klehm, five unidentified, and ? Meinke.

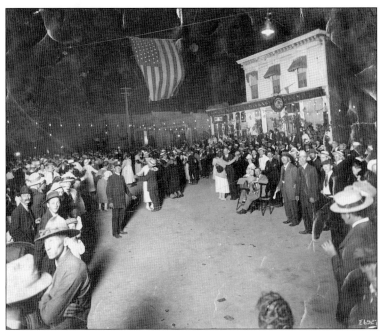

In celebration of the end of World War I, the streets of downtown Niles Center became a dance hall. Celebrants are dancing at the corner of Lincoln Avenue and Warren Street in front of Michael Schmitz's Saloon and Bowling Alley, which later became Duffy's Tavern. The saloon served as a lunchroom for the locals and possessed a very large horseshoe-shaped bar. Tenants' rooms were above the saloon.

Three

THE WESTERN EUROPEAN
SETTLEMENT
1921 TO 1949

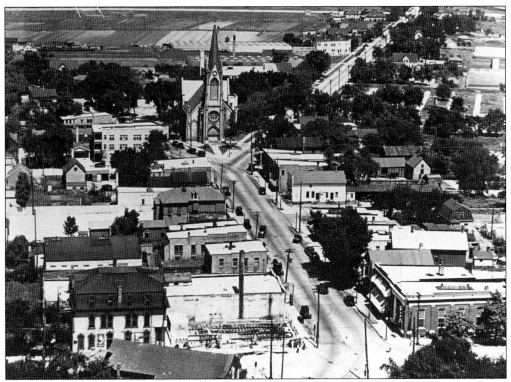

This 1926 aerial view of downtown Niles Center is focused on Lincoln Avenue and Niles Center Road. Among the several businesses visible are the Niles Center State Bank, Schmitz's Tavern, and the Even Shoe Store. Note the tracts of vacant land behind St. Peter Catholic Church. As a premonition of things to come, the Blameuser building has been moved from its original location at the corner of Oakton Street and Lincoln Avenue to make way for a new building. The moving of buildings and vacant land were indicative of a village poised to take advantage of the Roaring Twenties when tinges of suburbanization crept into the lives of Niles Center denizens. However, the Great Depression stalled further suburbanization until after World War II.

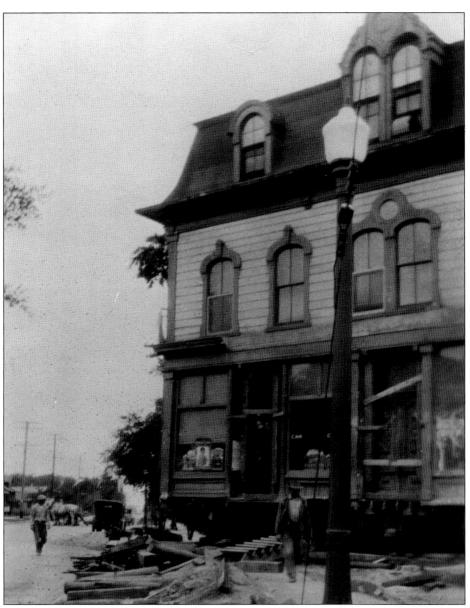

In 1926, during the Roaring Twenties, land values were escalating and old buildings occupying valuable land were impediments to development. The Blameuser building, pictured here, was built around 1857 by Peter Bergmann on the northwest corner of Lincoln and Oakton Streets. Bergmann then sold the building to Peter Blameuser II. Over the years, it housed a tavern, general store, and bank. However, in 1926 the building was removed from its foundation and moved approximately 150 feet west on Oakton Street, settled on a new foundation, and lived in for another 50 years before it was razed for a parking lot. In its place, the owner built what became known as the Desiree building (opposite page), named for the Desiree Restaurant that occupied the corner section of the building for many years. The National Bank of Niles Center, which opened in 1928, operated from the Desiree building at 5104 Oakton Street, the present site of Skokie Paint and Wallpaper. The bank's vault can still be seen in the paint store. On April 7, 1933, the bank was robbed, resulting in the murder of the bank's cashier, Harry Mueller.

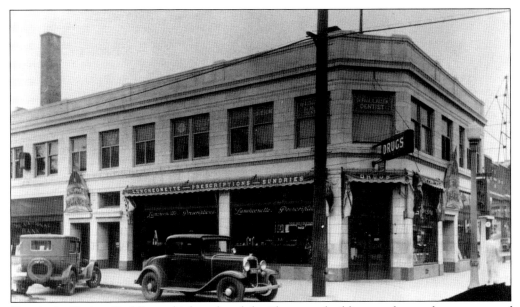

Here is the Desiree Building, which replaced the Blameuser building on the northwest corner of Lincoln Avenue and Oakton Street, where it still stands. A drugstore owned by Gerhart Monahan occupied a large portion of the building. Other occupants included the National Bank of Niles Center, the offices of Dr. Eva Line and Dr. A. Louise Klehm, and the dental office of Dr. Paul Allen. It was also in this building, in September 1929, that the Cosmos Club gave birth to what would become the Skokie Public Library.

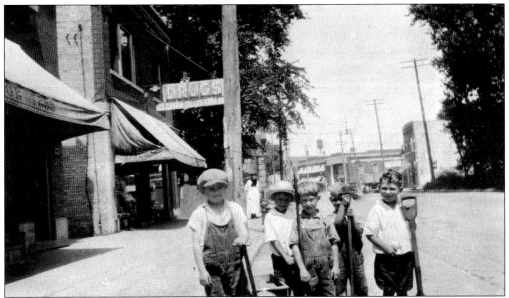

Pictured on Lincoln Avenue looking north from Galitz Avenue are, from left to right, Carl Peters, Harold Baumhardt, Samuel Meyer, Vernon Galitz, and Elmer Baumhardt. Taken around 1920, the following businesses are identified: George Tess Grocery Store and Niles Center Pharmacy. By 1938, Niles Center Pharmacy became Parker's Drugstore, owned and operated by W. J. Parker well into the early 1960s. Some may recall purchasing Green Rivers and Cherry Cokes at the store's soda fountain.

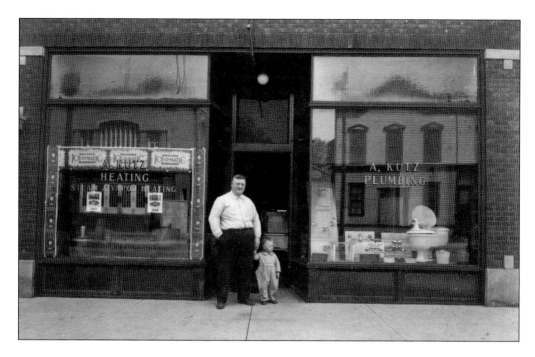

Pictured above around 1920 is the A. Kutz Plumbing and Heating store. This building still stands at 7919 Lincoln Avenue. The folks standing in front of the store are believed to be Walter Kutz and an unidentified son. Looking closely, one will see reflections of the Niles Center Theater and Meyer's grocery store in the front windows. Below is the Niles Center Theater, which Samuel Meyer built around 1915 at 7924 Lincoln Avenue. This building served as a movie theater until it was closed in 2000. In 2004, the Skokie Theatre Music Foundation acquired the building and renovated it into a 140-seat live music and performance venue.

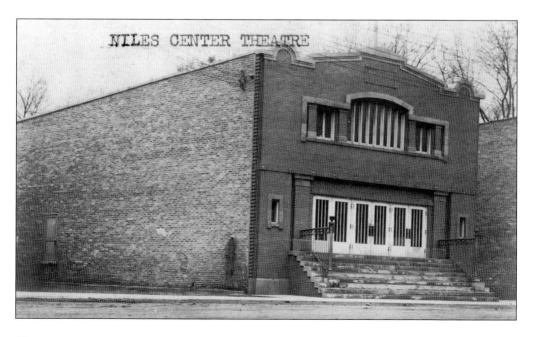

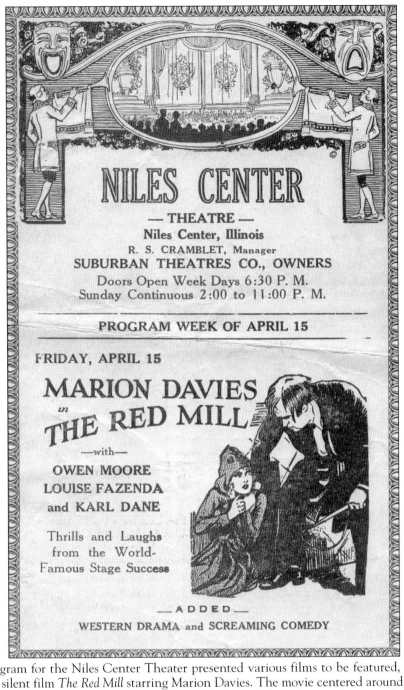

This program for the Niles Center Theater presented various films to be featured, including the 1927 silent film *The Red Mill* starring Marion Davies. The movie centered around Davies as a young Dutch woman named Tina who cleaned the mill floors by attaching scrub brushes to her feet and dancing around the floor. Her companion was a small mouse who lived in one of her wooden shoes. She falls in love with a visitor to Holland, but he leaves before anything can blossom. The plot is similar to *The Prince and the Pauper*, in that Tina and her friend, who is being forced by her father to marry someone she does not love, exchange places and the friend falls in love with the visitor Tina met months earlier.

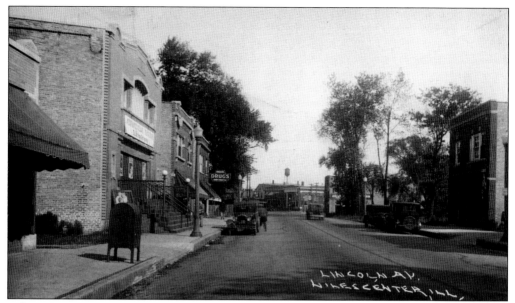

Taken after 1927, as indicated by the advertisement for talking pictures at the theater and the modern street lamps, this photograph depicts Lincoln Avenue looking north from Galitz Avenue toward Oakton Street. It is the opposite view of the picture depicted below. Seen here are, on the left, the Niles Center Theater, the George Tess Grocery Store, and in the distance, the Niles Center State Bank and the village's water tower. The A. Kutz plumbing business is located across from the theater on the right.

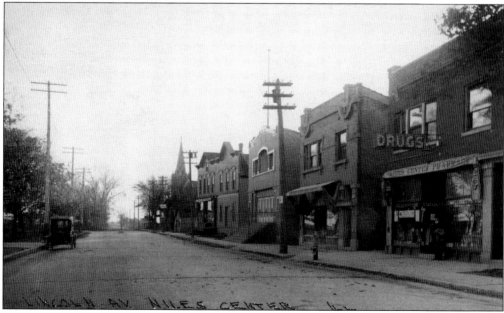

This postcard depiction of the 7900 block of Lincoln Avenue is looking south towards Galitz Avenue. The right side of this postcard depicts John Heick's Niles Center Pharmacy at 7928 Lincoln Avenue, George Tess Meat Market at 7926 Lincoln Avenue, the Niles Center Theater at 7924 Lincoln Avenue, the Meyer Grocery Store, and St. Paul Lutheran Church. The postcard was postmarked "Jul 15, 1926, Niles Center" and was affixed with a 2¢ stamp.

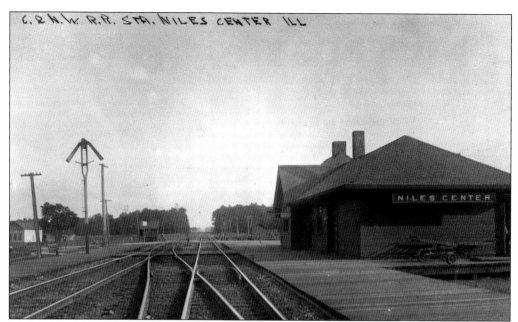

In 1903, the Northwestern Railroad built a branch line through Niles Center. Looking south toward Chicago, the station pictured here was at Oakton Street just west of Skokie Boulevard. This station was removed in the 1950s, as it was not needed. At this location, efforts are now under way to build a station for the Skokie Swift "L" train, which currently runs from Dempster Street to Howard Street in Chicago.

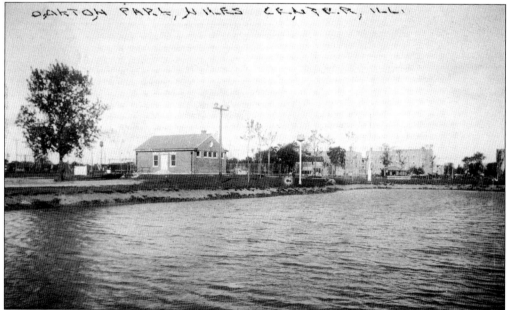

The Niles Center Park District was founded in 1928. Within a year, the district purchased approximately 62 acres of land from the Cook County Forest Preserve. Oakton Street, Brummel Street, Kenton Avenue, and Lincoln Avenue bound this land. Within these boundaries, Oakton Park and Emily Oaks Nature Center would be developed. Here is an early view of Oakton Park looking northwest toward Skokie Boulevard and Oakton Street.

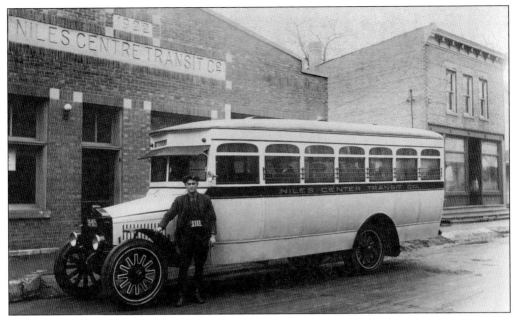

Tom Waller, Niles Center's first bus driver, poses with a bus in front of the Niles Centre Transit Company, which was located at 8102 Lincoln Avenue just north of Brown Street. This building still stands. Formed in 1922, the Niles Centre Transit Company's bus service remained in use until the end of World War II. This early bus route ran from Glenview through Morton Grove to Lawrence and Western Avenues in Chicago via Lincoln Avenue.

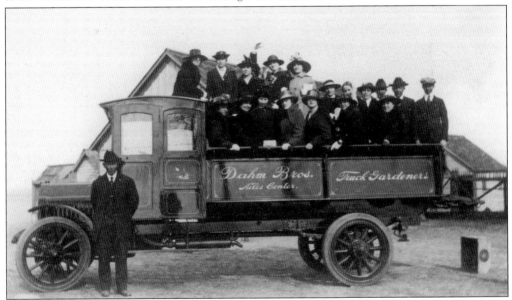

Dahm family members and friends, in their Sunday best, pose on the Dahm Brothers' truck. Continuing in the farming and greenhouse tradition, truck gardening (or truck farming) was a major enterprise in Niles Center as well as a major supplier of fresh produce. These truck farms predated the current farmers' markets. The Dahm brothers were the sons of Nicholas Dahm and consisted of John, Herman, Edward, Philip, Mathias, Peter, and Bernard, some of whom are pictured on page 37.

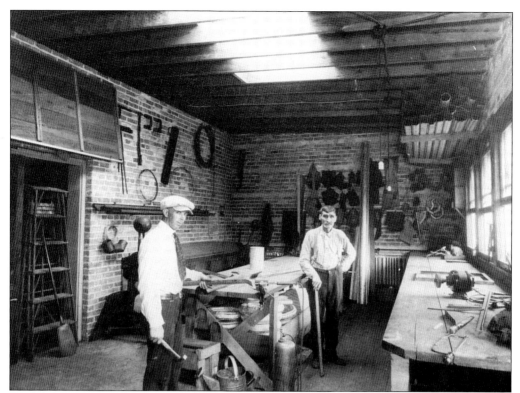

Frank A. Gabel, at left with tools in hand, and Medard Gabel, at right, pose in the workshop of Gabel's Hardware Store, located on Lincoln Avenue. Various items were produced in the shop, including building supplies such as sheet metal, pipes, gutters, and downspouts, which can be seen tucked away in the upper right corner of the shop.

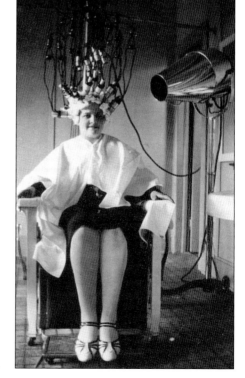

Despite suggestions that her beauty shop would fail in rural Niles Center, Elizabeth Ottlinger opened her first beauty salon on Brown Street in 1926. The business was such a success that, within two years, she moved into a larger and more modern salon on Lincoln Avenue. Pictured here is one of the salon's patrons receiving the latest style.

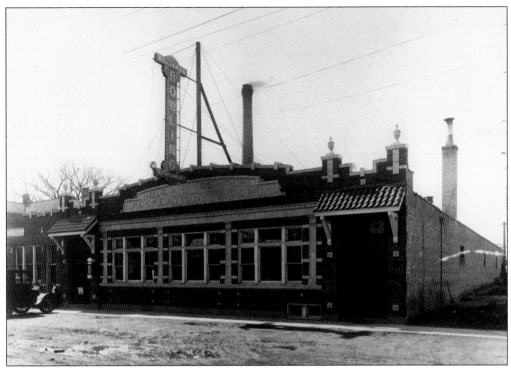

Built in 1925, the Niles Center Recreation Rooms were located at 8146 Floral Avenue on the northwest corner of Floral Avenue and Cleveland Street. Above is an exterior view of the building in the 1920s. The recreation rooms, owned by Al Lies Sr., included a 10-lane bowling alley with tin ceilings, pictured below. Later renamed Skokie Lanes, the building continued to serve as a bar and bowling alley until 2008 when it was torn down. The building's stone facade remained unchanged until its razing, serving as a reminder of Skokie's past; inlaid at the top of the building were stone tiles inscribed with "Niles Center Recreation Rooms."

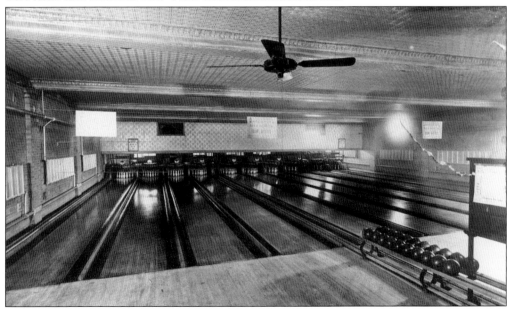

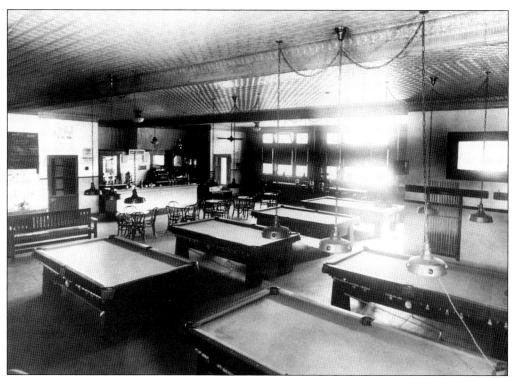

Above is another interior view of the Niles Center Recreation Rooms building. This view showcases the recreation rooms' tin ceilings, hanging lamps, bar, and pool tables. Besides a game of pool and bowling, patrons could also enjoy a game of mini golf on the miniature golf course outside just to the north of the building. Pictured below, a group of young women enjoy some ice cream while seated on the Niles Center Home Laundry truck. Behind them to the right is the Niles Center Recreation Rooms and to the left, the Niles Center Home Laundry building. Also built in 1925, the Niles Center Home Laundry building is still standing and, similar to the Niles Center Recreation Rooms building, holds a key to Skokie's past; the words "Niles Center Home Laundry Inc" are engraved into the building.

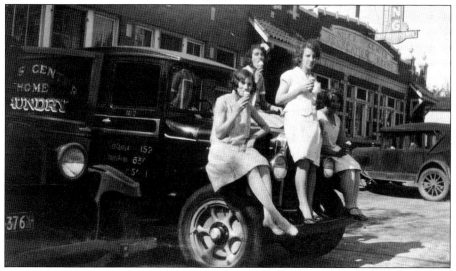

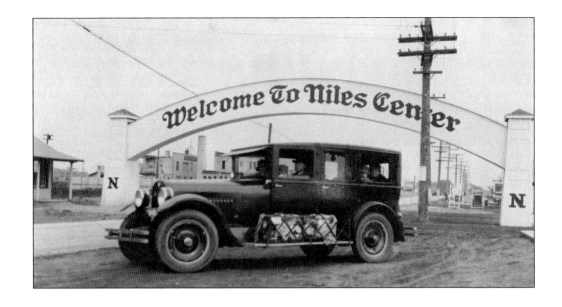

In 1924, Niles Center began annexing land surrounding its original boundaries, including sections to the north that encompassed Dempster Street and beyond. Pictured above, an archway on Dempster Street welcomes visitors from the north and west to Niles Center. In the hopes of drawing residents to the area, businesses and homes were constructed near Dempster Street. M. J. Flaherty purchased 100 acres north of Dempster Street and created a subdivision, which he named The Bronx, because Niles Center's proximity to Chicago reminded him of the Bronx's proximity to Manhattan. The Bronx Building, pictured below, was built in this subdivision across from the Dempster Street station, pictured on the opposite page. Built in 1927 as a symbol of prosperity and at a cost of $170,000, the interior of this massive stone building was filled with elaborate tile work and marble staircases. The Bronx Building still stands.

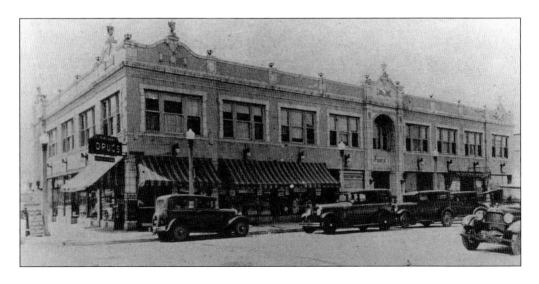

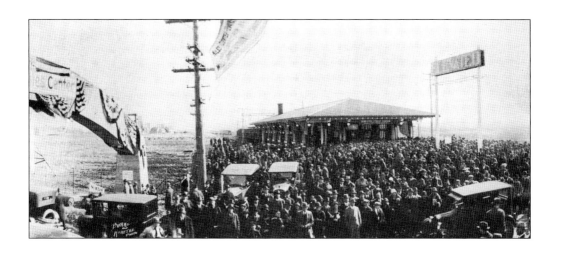

In 1924, an electric railroad line was constructed from Howard Street in Chicago to Dempster Street. Pictured above is the grand opening of the Dempster Street station in 1926. On the left, one can see the "Welcome to Niles Center" archway that is visible on the opposite page. Below is another view of the station. The prairie style station continued to be used for a variety of purposes until an updated Skokie Swift station was built in 1993. Thereafter, it became a pigeon roost and was in danger of being razed. However, the Skokie Historical Society and other concerned citizens inspired preservation efforts, so the old station was saved and moved east of its original location. In 1996, the building was listed on the National Register of Historic Places and is presently occupied by Starbucks.

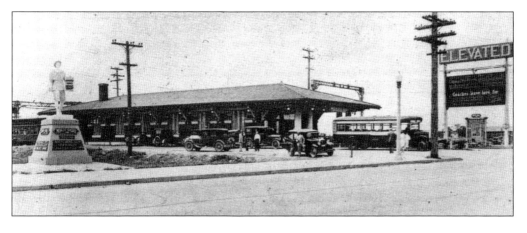

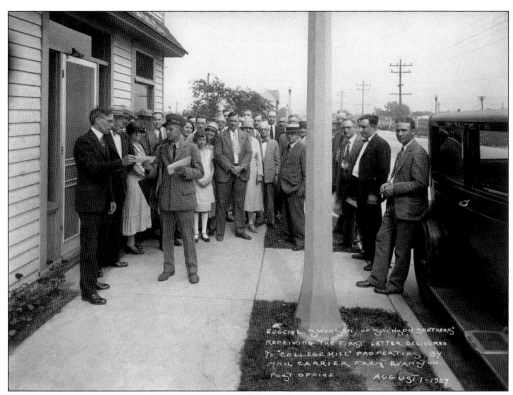

EUGENE SWENSON OF SWENSON BROTHERS
RECEIVING THE FIRST LETTER DELIVERED
TO "COLLEGE HILL" PROPERTIES BY
MAIL CARRIER FROM EVANSTON
POST OFFICE AUGUST 1-1927

Another subdivision that arose in the Evanston–Niles Center area was College Hill. Located in the northeast section of Niles Center near Evanston, the subdivision's boundaries were Dempster Street, McDaniel Avenue, Emerson Street, and Hamlin Avenue. Swenson Brothers developed the subdivision, which included apartments, bungalows, and a school. This subdivision is located within the municipal boundaries of Niles Center. However, the Evanston Township High School district served College Hill then, as it does today. Pictured above, Eugene Swenson of Swenson Brothers receives the first mail in College Hill from an Evanston mail carrier. Evanston's post office continues to deliver mail to this area. At left, two children with a watering can and bell in hand pose inside the College Hill School. Opened in 1926, the small wood frame school was located on the southeast corner of Church Street and Prairie Road, two blocks west of McCormick Boulevard.

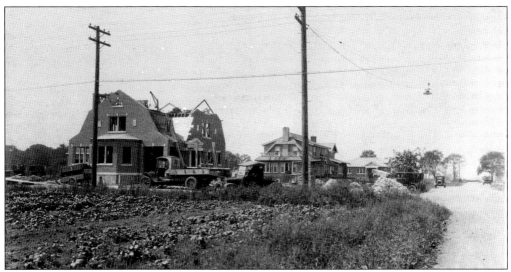

Above is a juxtaposition of Niles Center's past and present, as new homes are constructed next to fields of leafy produce at Laramie Avenue and Brown Street. This photograph is a reflection of the short-lived real estate boom experienced in the 1920s. In anticipation of population growth due to the boom, Niles Center completed many water, sewer, and paving projects and expanded its boundaries through annexation. However, the Great Depression would abruptly end the boom, leaving Niles Center with many paved but unoccupied streets, which would remain so throughout the Depression. This boom and bust can be seen in the 1930 aerial view below. The view centers on the intersection of Lincoln Avenue and Oakton Street. The boundaries pictured in the photograph reach from Church Street to the north, Niles Avenue to the east, Lorel Avenue to the west, and George Street to the south.

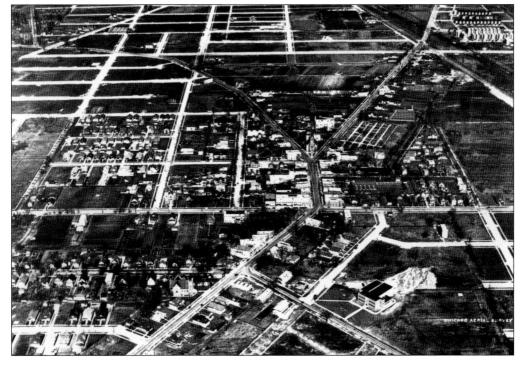

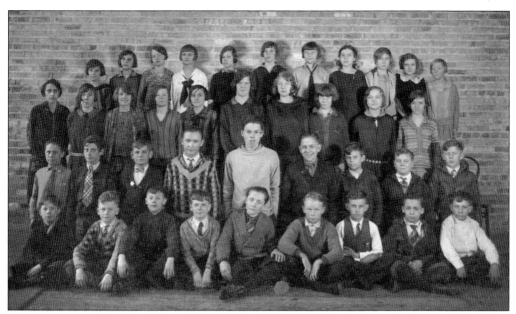

Pictured above, students of South Niles Center (Fairview) School pose for a class photograph in 1928. The students are, from left to right, (first row) Carl Goberville, Willard Rohde, Clarence Moll, unidentified, Norman Lindemann, Paul Risinger, Ralph Kasten, unidentified, and Elmer Baumhardt; (second row) Weidner Riske, unidentified, Edmund Henning, Irv Miller, Roland Henning, unidentified, Milton Grosse, Elmer Ide, and Willard Gross; (third row) unidentified teacher, Julia Eby, Ethel Honickel, Frieda Fleming, Ella Burmeister, Mable Glauner, Grace Lange, Emma Peters, Louise Lenz, and Ella Ferris; (fourth row) Audrey Goberville, Edna Wohlbrant, Rita Dwyer, Doris Schnable, Evelyn Kenning, Lucille Lange, Olga Munch, Blanche Brunger, Marion Ruesch, Viola Esch, and Gladys Baumann. Students also enjoyed extracurricular activities like sports. Below are members of the 1930 Niles Center girls' basketball team outside Lincoln School.

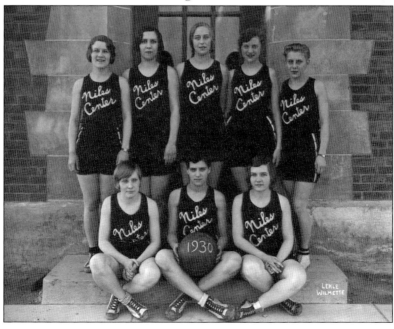

In 1928, Niles Center School, later renamed Lincoln School, opened with 202 students in attendance. Additions were made to the building in 1932, 1935, 1952, and in the 1970s, and in the 2000s. In 1978, Lincoln School became Lincoln Junior High School and taught only grades six through eight. The 1936 kindergarten class is pictured working on an art project with the aid of their teacher.

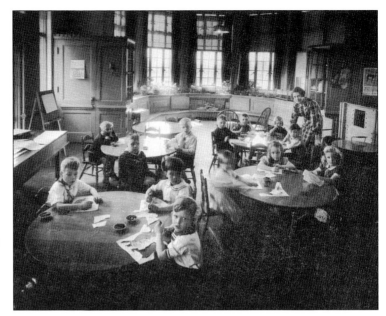

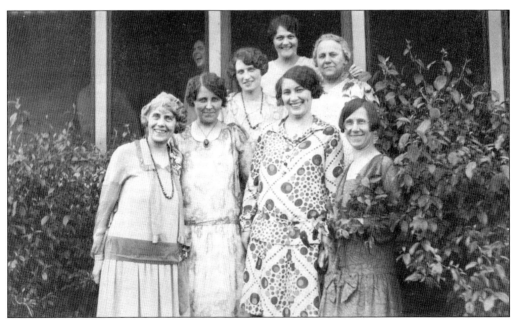

Pictured here are members of the Woman's Club of Niles Center, which was founded in 1926 as a service organization. During the Great Depression, they worked with the Joint Emergency Relief Organization to aid residents. The club continued to aid the village after the Depression with beautification projects, war effort assistance, and in the 1950s, by helping servicemen who were stationed at the antiaircraft battery located on the future site of Devonshire Park.

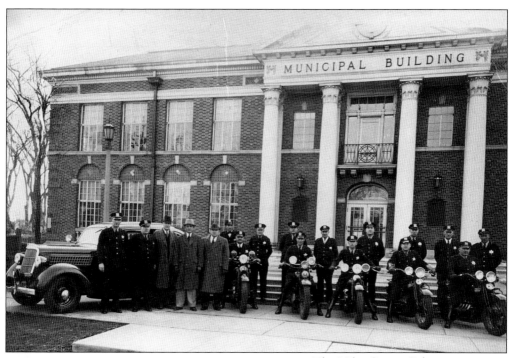

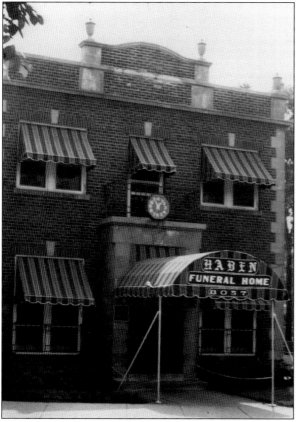

The Niles Center Police Department, formed in 1932, joins village officials on the front steps of Village Hall with a police squad car and motorcycles. The police department offices and jail were located in the basement of Village Hall from 1927, when the Village Hall was built, until 1956, when a separate police department building was constructed.

Bradley and Haben Funeral Services established a funeral home in Niles Center in 1923. In 1929, Ray Haben built the structure pictured here at 8057 Niles Center Road, and the building was expanded in the early 1950s. In 1934, Ray Haben received an anonymous tip that the body of gangster George "Baby Face" Nelson was dumped near St. Paul Lutheran Cemetery. G-men then escorted his body to Haben's for storage. Haben Funeral Home is the oldest continuous commercial family-owned business still in operation in Skokie.

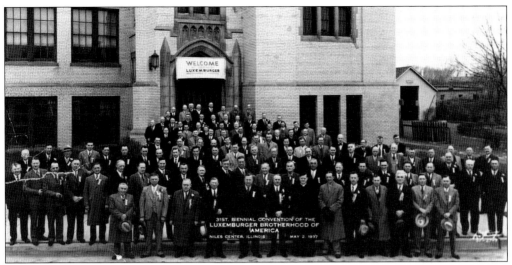

Above in 1937, the Luxembourg Brotherhood of America (LBA) convened for its 31st biennial convention in Niles Center at St. Peter Catholic School. Section 15 of the LBA was founded in Niles Centre in 1905. Presently it is Skokie's oldest continuous club still in existence. The Luxembourg immigrants began arriving in Niles Center about 1885 and established greenhouses and truck farms for the sale of flowers, vegetables, and other produce. The photograph below was taken in 1938 during the presidency of Martin "Scotty" Krier who was, at the time, the Democratic committeeman of Niles Township. The southeast corner of Lincoln Avenue and Oakton Street is now known as Krier Plaza. Pictured from left to right are (first row) Nick Kalmes, Pat Seul, Martin "Scotty" Krier, Paul Hermes, and Joseph Freres; (second row) Anton Krier Jr., Anton "Tony" Seul, Val Krier, Bill Biegert Sr., and Adam Hohs.

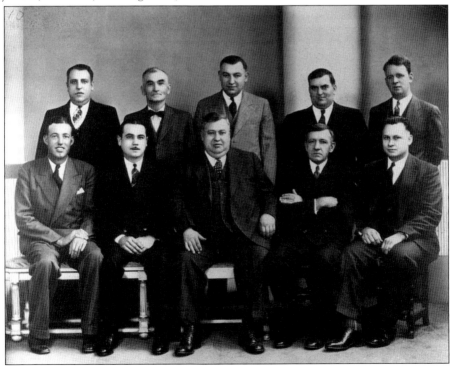

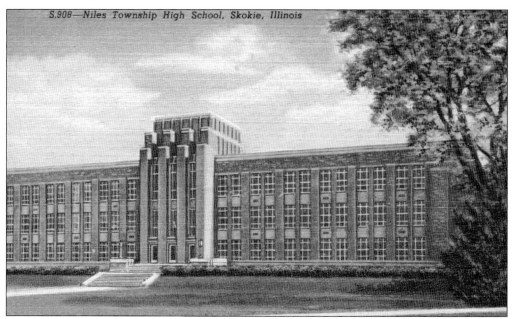

S.908—Niles Township High School, Skokie, Illinois

This postcard is a sketch of Niles Township High School, which was built in 1939 as a WPA project at a cost of over $750,000. Prior to its construction, from 1931 to 1939, high school classes were held at Lincoln School. There were 457 students in attendance when the high school opened, which was approximately 10 times the student population when high school classes were first held at Lincoln School.

This is a photograph of members of the Niles Township High School Board of Education. When the school was built in 1939, the board members were Mildred E. Tess, president; Raymond C. Klehm, secretary; Ivan M. Paroubek, chairman of the building committee; Frank Ambler; Mack D. Falknor; Peter J. Kluesing; and Roy A. Whiteside, attorney. Pictured here are, from left to right, Peter J. Kluesing, Ivan M. Paroubek, Mildred Tess, Mack D. Falknor, and Frank Ambler.

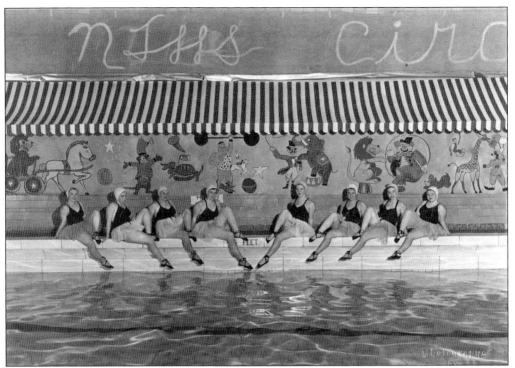

Niles Township High School's extracurricular activities included synchronized swimming and football. The girls' synchronized swim team poses above in costume for the annual water carnival. Both the girls' synchronized swim team and the boys' synchronized swim team participated in this carnival, which had themes such as the circus, pictured here, and the Wizard of Oz. Support of war efforts was reflected in their carnival formations during World War II, as they formed slogans such as "Victory." The football team poses below on the school's football field. In the distance, several houses can be seen across Lincoln Avenue fronting on Niles Center Road. (Above, courtesy of Nick Bosnos.)

DELEGATE	Ridgemoor Yes	No	Oaklyn Yes	No	Westridge Yes	No	Skokie Yes	No
Jos. Hanson	X							
W.K. Lyon							X	
Sigmund J. Chakow	X							
Howard Florus			X					
Mrs. J.J. Mussel			X					
Mrs. Wm. F. Barkow					X			
Mrs. Miles Babb			X					
Mr. Budd Reesman							X	
Mae Schoeneberger								
Allan A. Weissburg					X			
Arthur C. Thompson							X	
Geo. D. Wilson							X	
Paul Clark							X	
Ernest Martin							X	
Armond D. King							X	
Geo. Waldmann							X	
Mrs. Ray Morrison			X					
Geo. E. Blameuser							X	
Ambrose Brod							X	
Willard Galitz							X	
Russell Tucker								
Thos. Rae							X	
J. Walter Wuerth							X	
Peter Conrad							X	
							X	

In 1936, the locals grew tired of the rural sounding name of Niles Center. In 1939, Scotty Krier formed a committee to search for a more modern name befitting the village. In response to the committee's request, approximately 1,100 names were submitted for consideration. The committee then narrowed the selection to the following five names: Ridgemoor, Oaklyn, Westridge, Woodridge, and Skokie. As the table indicates, in the vote taken August 9, 1940, the electors favored Skokie over Oaklyn by 15 to 4.

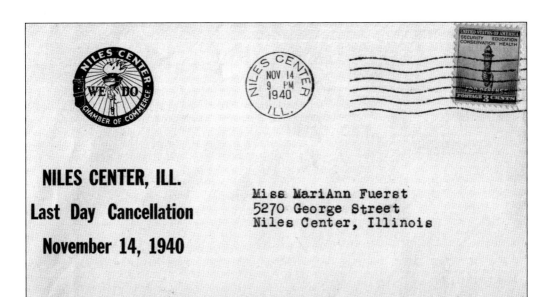

After the name change committee, which consisted of private citizens, submitted its recommendation to the village board, it was necessary to register the change with the Illinois Secretary of State, who determined that the change would be effective at 12:01 a.m. on November 15, 1940. Thereafter the U.S. Postal Service was notified, and the pictured envelopes were developed to announce Skokie's new name to the outside world. Seen here are two envelopes received by Niles Center/Skokie resident MariAnn Fuerst: one announcing the demise of Niles Center, and the other announcing the christening of "Skokie, Illinois—Gateway to the Skokie Valley."

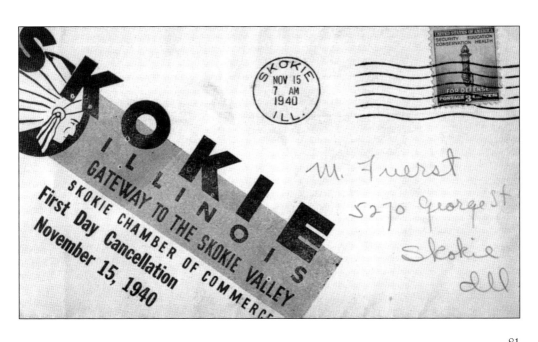

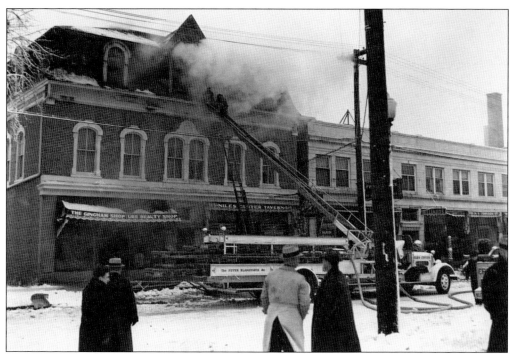

On November 27, 1940, a fire in the Blameuser building, relocated to 5116-18 Oakton Street, left nine families homeless, including that of Skokie firefighter Oscar Siemsen. Residents look on, above, as firefighters from Skokie, Evanston, and Morton Grove fight the blaze, attempting to save the Gingham Shop, Ure Beauty Shop, Niles Center Tavern, and the apartments above. The apparatus above was Skokie's first electrically powered aerial ladder fire truck. It was named after Peter Blameuser II, who is pictured on page 23. Pictured below, female residents are serving coffee to exhausted firefighters during a much needed break. Businesses in the distance include Sinclair Gas Station, a Pontiac car dealership, and Niles Center State Bank.

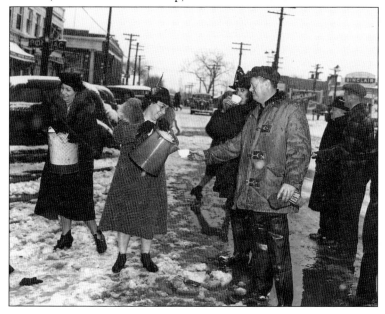

After World War II, many servicemen and their families moved from Chicago to Skokie. The photographs here represent some of these families. In the photograph below, Robert Lindstrom poses in his naval uniform outside his family's Chicago home before he goes off to war. At right is a photograph of Helen Swanson. Helen's photograph was kept in a keepsake wallet with naval insignia on the cover by her husband, Eric, who took the wallet with him as a remembrance of the girl he left behind when he joined the navy. Many residents of Skokie were also in the armed forces at the start of and during World War II. While stationed in Hawaii, Skokie resident Gordon Mitchell was killed on December 7, 1941, during the attack on Pearl Harbor.

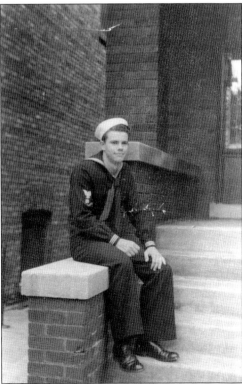

FORM 1040 Treasury Department Internal Revenue Service	UNITED STATES **INDIVIDUAL INCOME AND VICTORY TAX RETURN**	Page 1 **1943**

1939 – 3209
1940 – 3478 – P 40.44
1941 – 3515 – P151.47
1942 – 3591 – 361.10
90.28
1943 – 3791 – 498.44

OPTIONAL FORM 1040A MAY BE FILED INSTEAD OF THIS FORM IF GROSS INCOME IS REPORTED ON THE CASH BASIS FOR THE CALENDAR YEAR, IS NOT MORE THAN $3,000, AND CONSISTS *WHOLLY* OF SALARY, WAGES, OTHER COMPENSATION FOR PERSONAL SERVICES, DIVIDENDS, INTEREST OR ANNUITIES

FOR CALENDAR YEAR 1943

or fiscal year beginning _____, 1943, and ending _____, 1944

PRINT NAME AND ADDRESS PLAINLY. (See Instruction C)

(Name) (Use given names of both husband and wife, if this is a joint return)

(Street and number, or rural route)

(City or town)　　　　(State)

Occupation _____ Social Security number, if any _____

(Do not use these spaces)

File Code
Serial No.
District
(Cashier's Stamp)

COMPUTATION OF NET INCOME

	Column 1 Income Tax Net Income	Column 2 Victory Tax Net Income

In 1913, the 16th amendment to the U.S. Constitution was finally ratified by the states and the loathsome income tax was levied on the people. During the World War II years, Uncle Sam labeled his 1040 as the "Individual Income and Victory Tax Return" as pictured above. This euphemism was supposed to make one feel good about sending hard earned money to the government. At least one's tax dollars were spent to support a good cause—the defeat of the Nazi and Japanese war machines. Pictured below is the essential war ration book of Skokian Leonard F. Baumann. This book contained stamps, which were used during World War II to obtain those things that were plentiful before the war but during the war became scarce.

57328 BG

UNITED STATES OF AMERICA
OFFICE OF PRICE ADMINISTRATION

WAR RATION BOOK FOUR

Issued to *Leonard F. Baumann*
(Print first, middle, and last names)

Complete address *4960 Warren St.*

Skokie Illinois

READ BEFORE SIGNING

In accepting this book, I recognize that it remains the property of the United States Government. I will use it only in the manner and for the purposes authorized by the Office of Price Administration.

Void if Altered _____
(Signature)

It is a criminal offense to violate rationing regulations.

OPA Form R-145　　　　　　　16—35570-1

A prominent and recognizable structure on the southern border of Skokie, Elliot's Pine Log Restaurant and Lounge was located at 7545 Skokie Boulevard (Cicero Avenue), at the intersection of Howard Street and Skokie Boulevard. Established in the early 1940s, the restaurant was a reminder of Niles Center's tavern- and speakeasy-filled past. Surviving a 1955 fire that cost nearly $250,000 and injured two firefighters, the restaurant stood until it was razed in 1989 to make way for condominiums. Above is a photograph of the restaurant's sign, taken before the building was demolished. Below is a postcard of Elliot's Pine Log Restaurant and Key Hole Bar postmarked May 8, 1947. (Above, courtesy of Julian Jablin.)

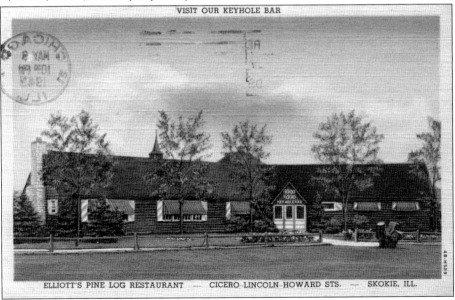

VISIT OUR KEYHOLE BAR

ELLIOTT'S PINE LOG RESTAURANT — CICERO-LINCOLN-HOWARD STS. — SKOKIE, ILL.

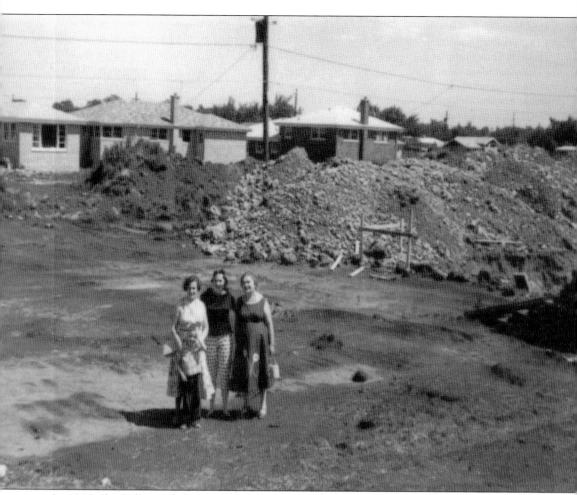

In 1946, the Village of Skokie adopted a master plan that would emphasize the construction of single-family homes. By 1954, Skokie would lead all suburbs in the issuance of single-family building permits and apartment construction. The real estate boom that had been forestalled by the Great Depression in 1929 was now afoot and would fill the previously vacant streets of Skokie. By 1961, there would be 11,773 single-family homes, 571 two flats, 118 three flats, 397 co-ops, and 164 townhouses in Skokie. The Berman family is pictured standing at the site of their future home at 9339 Kostner Avenue in 1955. Their house would be one of the many ranch homes built during this era. Several more ranch-style homes can be seen behind them.

Four

THE JEWISH ARRIVAL
1950 TO 1980

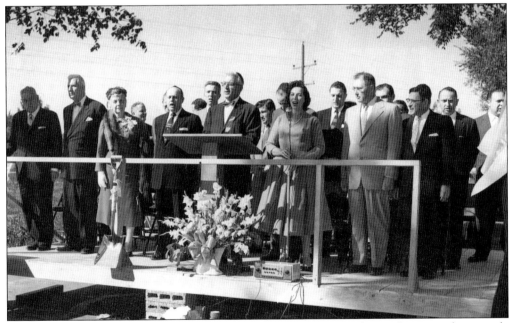

During the early 1950s, Skokie's ethnic and religious mix began to change from a predominantly Christian community of Catholics and Protestants to one that included their elder Messianic brother—Judaism. As the Edens Highway made access to the northern suburbs easier, residents of Chicago's south and west sides headed for Skokie in larger numbers. Pictured here is the ground-breaking ceremony for Skokie Valley Traditional Synagogue, which was built in 1956 at 8825 East Prairie Road. Among the participants was Sen. Paul Douglas, who is pictured second from the left. Next to him, on his left, is Congresswoman Marguerite Stitt Church, and next to her is Sam Berger, who was later elected as a village trustee. Rabbi Karl Weiner, who was later elected as a trustee of the Skokie Public Library, presides at the podium. Skokie mayor Ambrose Reiter is immediately to the left of the unidentified woman singing at the center. Among the Jewish institutions that called Skokie their home were the Hebrew Theological Seminary, Temple Judea Mizpah, and Niles Township Jewish Congregation. (Courtesy of Modes Photography.)

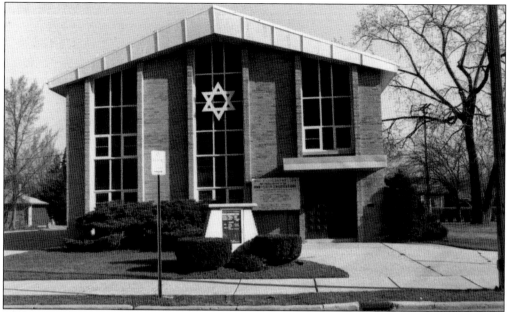

The Iran Hebrew Congregation (Persian Hebrew Congregation) was founded in Chicago in 1910 but moved to Skokie in the late 1950s. The Iran Hebrew Congregation Synagogue, pictured here, was built at 3820 Main Street. By the 1980s, the number of synagogues in Skokie would grow to 10. The establishment of so many synagogues, including the Iran Hebrew Congregation above, was indicative of the tolerant atmosphere that Skokie fostered. (Courtesy of Doris Sopkin.)

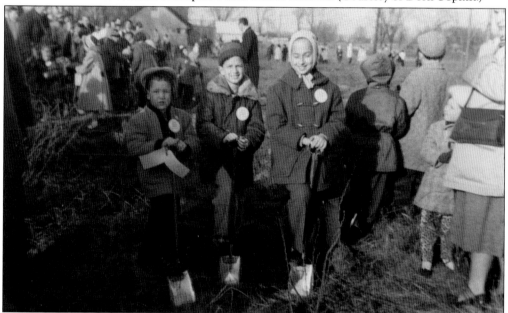

Children assist in the ground-breaking ceremonies for the Niles Township Jewish Congregation Synagogue located at 4500 Dempster Street. As the first organized Jewish congregation in Skokie, the congregation held its first services in Skokie's Village Hall in 1952. Until the synagogue was completed in 1959, services were held in a variety of locations. The congregation was organized under the leadership of Rabbi Sidney Jacobs. (Courtesy of the Poholsky family.)

The Skokie Valley Conservative Congregation was founded in 1953. A year later, construction began on their synagogue at 9131 Niles Center Road, pictured above, and the congregation was renamed B'nai Emunah. From 1954 through 1959, the congregation grew from 20 families to 600 families. Even though Skokie promoted a climate of tolerance, B'nai Emunah's facade was bombed in a Halloween prank in 1956. Founded at approximately the same time as B'nai Emunah in 1954, Temple Judea of Niles Township, pictured below, is located at 8610 Niles Center Road. Both congregations have since combined with congregations in other communities. Temple Judea combined with Temple Mizpah of Rogers Park in 1977, becoming Temple Judea Mizpah; B'nai Emunah combined with Beth Hillel Congregation of Wilmette in 2004. B'nai Emunah's original structure is no longer a synagogue but is now home to the Caldo Assyrian Community Center.

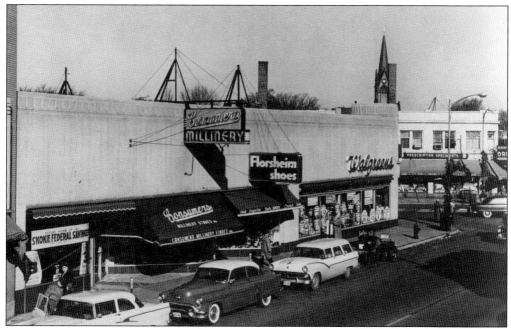

These views of Lincoln Avenue are representative of Skokie's post–World War II development into a suburban community. The view above is of Lincoln Avenue south of Oakton Street. Businesses visible in the photograph include Skokie Federal Savings, Consumer Millinery, Florsheim Shoes, and Walgreens Drugs. The building in which these businesses are located is still standing and presently is home to Bank of America. The view below is of Lincoln Avenue looking north from Oakton Street. Some of the businesses visible on the left are Oakton Drug, Skokie Camera, Skokie Cleaners, Skokie Variety, Krier's Restaurant, and Schmitz's Tavern. St. Peter Catholic Church is in the center at the intersection of Lincoln Avenue and Niles Center Road. The First National Bank of Skokie is visible on the right.

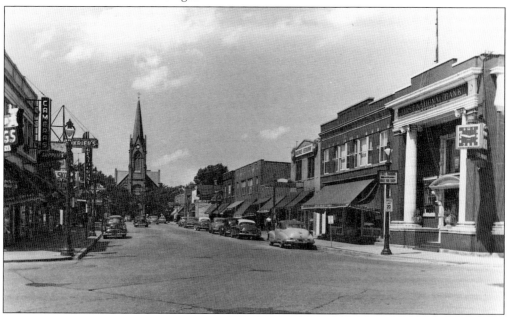

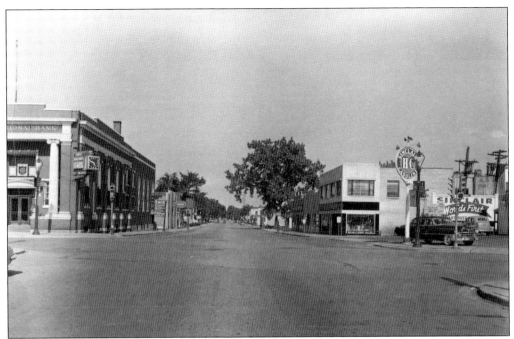

Presented here are more views of downtown Skokie taken from the intersection of Oakton Street and Lincoln Avenue. The view above is looking east along Oakton Street. In this photograph, Urbanus's Sinclair Gas Station and the First National Bank of Skokie are visible. The view below, bustling with cars and pedestrians, is looking west along Oakton Street. Businesses visible include Walgreens Drugs, Skokie Jewelers, Orchid Cleaners, King Realtors, Alice Beauty Shop, Oakton Drugs, and Skokie Camera. The steeple of St. Peter's Evangelical Lutheran Church protrudes over the trees in the distance. The two buildings that dominate this photograph still stand in downtown Skokie.

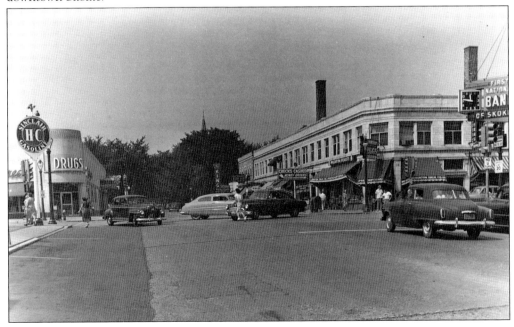

The photograph above was taken prior to 1952 from the front door of St. Peter Catholic Church. On the right side is a wooden storage building, which was part of the Schoeneberger General Store. In 1952, the wooden storage building was demolished and Alberti's Italian Restaurant began operating from this site. Presently the Village Inn Pizzeria, Sports Bar, and Grill operates from this location. A remembrance of Alberti's, a stained glass window is displayed in the Village Inn.

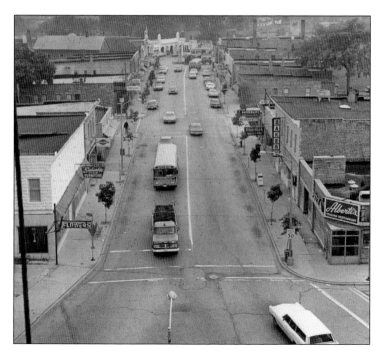

This view of downtown Skokie was taken from the steeple of St. Peter Catholic Church. Comparing this view to the photograph taken nearly 60 years prior on page 30, one can see Skokie's transition from a small rural community with dirt roads to a prosperous suburb. In this photograph, Alberti's can be seen on the lower right. No longer visible, Duffy's Tavern (Schmitz's Tavern), a fixture for over 75 years, was torn down and replaced with a parking lot.

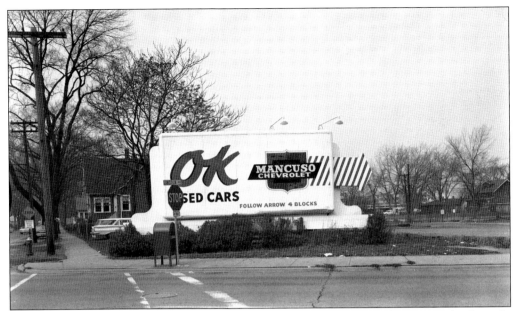

Pictured above is a billboard that guarded the gateway to downtown Skokie. Located at Lincoln Avenue and Galitz Street, the sign informed travelers to visit Mancuso Chevrolet, which was then located on Lincoln Avenue across from St. Peter Catholic School. A subsequent advertiser was G. D. Searle and Company. A housing complex for senior citizens now occupies the site.

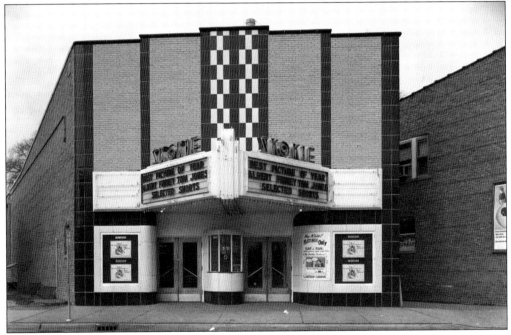

Shown here is the Skokie Theater, which until June 1932 showed silent movies. Over the years, its outside facade has changed. In the photograph on page 43, one can see steps leading to the entryway. Years later, these steps were removed, and the entryway is now at ground level. This photograph clearly shows the theater as it exists today, although rather than showing movies, it now showcases live music and performing arts.

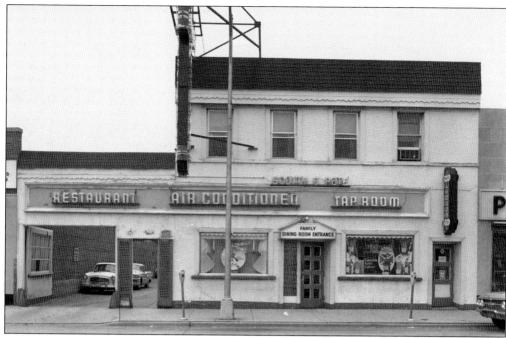

Pictured above at 8014 Lincoln Avenue is Krier's Restaurant, which was operated by Martin "Scotty" Krier and his brother, Peter Krier. One can see the name of the restaurant, Scotty and Pete's, above the doorway. The restaurant was famous for its steak sandwiches and gambling. Today it is a Chinese Restaurant and also houses Duffy's Lounge. Skokie's first restaurant to serve Chinese-American cuisine was the Canton Restaurant, below, located at 8007 Lincoln Avenue across the street from Krier's Restaurant. The restaurant opened around 1955. This photograph was taken prior to its demolition to make way for the First National Bank of Skokie tower, which was constructed in 1973.

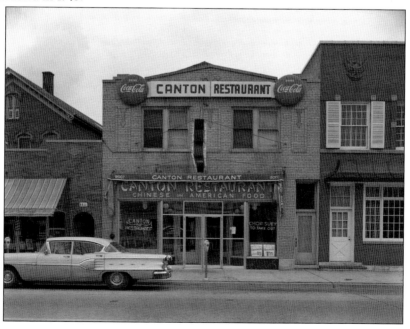

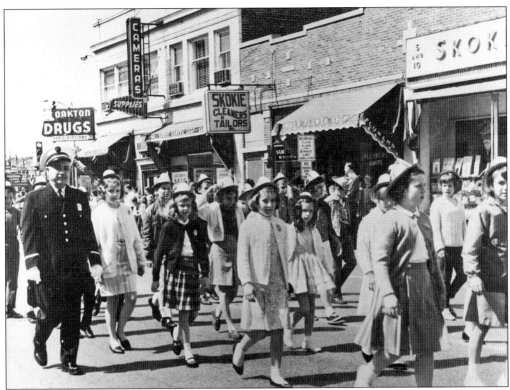

When Ray Redick became fire chief in June 1959 with the aspiration of achieving the coveted ISO Class 1 distinction for Skokie's Fire Department, the Fire Prevention Bureau (FPB) was expanded. Led by Lt. Francis "Pat" Seul, the FPB was then and is today very active in educating both the general public and school children in fire safety. Pictured above is Lieutenant Seul with the junior fire marshals marching on Lincoln Avenue just north of Oakton Street. This photograph and the one below were taken some time prior to June 1967, as Oakton Drugs is still on the corner. In the picture below, one can see the sign for the 8 Ball Billiards parlor. At the time, many parents were opposed to the parlor as a den of iniquity, an attitude reminiscent of the scandalized River City parents in *The Music Man*.

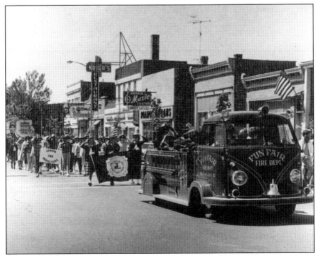

G. D. Searle and Company came to Skokie in 1941 when it constructed the building pictured above at a cost of $390,000. Located at 4901 Searle Parkway, this building still stands, although it is now the home of the Illinois Science and Technology Park. Before Searle was subsumed by Monsanto Company in 1985, it manufactured the first birth control pill in 1960, and its scientists discovered aspartame in 1965.

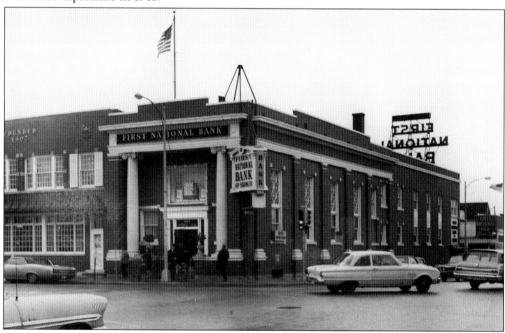

Pictured below is the First National Bank of Skokie, which occupied this site at 8001 Lincoln Avenue from 1916 until it was purchased by the U.S. Ameribancs group in 1986. One year later, the National Bank of Detroit purchased the U.S. Ameribancs group and the First National Bank of Skokie no longer existed. It became known as NBD-Skokie. Some local wags christened the bank "No Big Deal-Skokie." This picture was taken around 1965. (Courtesy of Robert Louis.)

The Skokie Park District's first community center and pool were constructed in 1958 at Devonshire Park. However, demand for another pool and community center became apparent as the population continued to grow. Oakton Community Center and Pool opened in 1961. Skokie residents are enjoying Oakton Park's pools below. After their swim, patrons could then walk across Oakton Street and grab a hot dog or other culinary delights at the Corner Hut, pictured above. Also visible in this view of Oakton Street, just east of Skokie Boulevard, are Township Auto Supply and a Sunoco gas station.

Here are two views of Oakton Park prior to the construction of Oakton Community Center and Pool. The land, presently occupied by Oakton Park, was the first land acquisition made by the Niles Center Park District in 1929. In 1951, recreational programming was transferred from the village to the park district. Reflective of Skokie's suburban development, the park district grew by leaps and bounds as more park space and recreational opportunities were demanded by Skokie's new residents. In 1955, a pivotal year in the park district's expansion, Skokie's electors passed a referendum allowing the park district to purchase and develop 17 parks, as well as the community center and pool at Devonshire Park.

In 1949, a second fire station was opened on Hamlin Avenue to accommodate the needs of Skokie's increasing population. Known as Station 17, it would remain in operation until 2003, when the newly built Station 17 at 8157 Central Park Avenue replaced it. Personnel pose in front of Hamlin Avenue Station in 1956. Identified are, from left to right, Capt. Pete Jaeger, Bob Burke, Bernie Weber, Rich Baumhardt, Al Suckow, Russel Van, and Fred Witt.

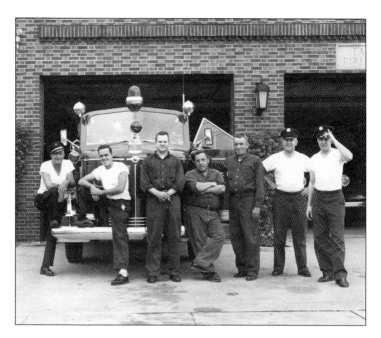

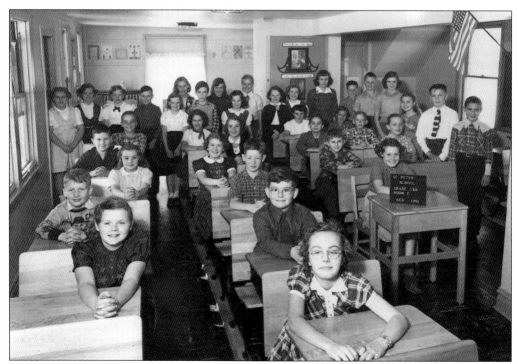

Students from St. Peter Catholic School's fifth and sixth grades pose at their desks in 1951. Among the identified students are, from left to right, Joseph Witry Jr. (second row, third from front) and Joseph Dockendorff Jr. (fourth row, first desk). With the baby boom and influx of families moving to Skokie, school populations swelled. This increase is reflected in the attendance records of St. Peter Catholic School, whose enrollment increased from 243 enrollees in 1928 to 1,270 in 1963.

A remnant of Skokie's past is the Hacker's farm stand and greenhouses. In 1864, the Hacker family purchased 30 acres from Henry Harms near the northwest intersection of Touhy Avenue and Niles Center Road (Carpenter Road) and operated greenhouses at that location. The southern portion of the Hacker property, which included greenhouses and the farm stand, was sold to the McDonald's Corporation in 1985. Thereafter, the family opened a garden center on the northern portion of the property. The center closed in 1999. Above is an image of the farm stand in the 1960s. Some may remember purchasing Hires Root Beer and Orange Crush soft drinks from the coin operated ice chest. Pictured below in front of the greenhouse, Jean Hacker stands next to a horse while Glenn Hacker poses atop the horse. These horses were part of the last team of workhorses to be used in Skokie. (Courtesy of Ruth Hacker.)

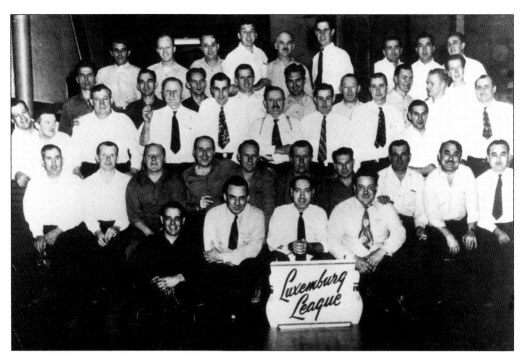

Pictured above is a photograph of the LBA Bowling League, taken at the Skokie Lanes. Seated in the front row, far right, is Nick Hoffmann, who operated a truck farm at 3700 Touhy Avenue. In the third row, fourth from the left, is Hubert Hansen who, with his brother Joe Hansen, built more homes in Skokie than just about anyone else. Hansen Radler Realty, Ltd., still operates in Skokie. In the second row, second from right, is Pat Seul, who is pictured on pages 49 and 95.

Martin "Scotty" Krier—member of the Skokie Chamber of Commerce, Democratic committeeman of Niles Township, and president of Section 15 of the Luxembourg Brotherhood of America—was also the patron of the semiprofessional Skokie Indians baseball team. Pictured below, the Indians played their home games at Oakton Park until the mid-1970s.

Rogers Park, Evanston, Skokie, Morton Grove, and Lincolnwood were all populated in part by immigrant families from Luxembourg. In the 1920s and 1930s, it was said that one could not purchase a cut flower unless it had been grown in a greenhouse located in one of those villages. In 1963, President Kennedy invited Luxembourg's head of state, Grand Duchess Charlotte, to America on a state visit. After being wined and dined in Washington, D.C., as a guest of the president, the grand duchess came to Chicago to visit with the sons and daughters of those who emigrated from her tiny grand duchy. On May 3, 1963, surrounded by secret service personnel and police from Skokie and Morton Grove, the grand duchess was feted at a reception held at the Luxembourg Gardens, then located on Lincoln Avenue in Morton Grove. Seen here, the grand duchess is accompanied by Skokian Joseph J. Witry Sr., then consul of Luxembourg in Chicago.

American Legion Post 320 was founded in 1931 and met in the Village Hall until 1945 when it purchased the Swedish Castle Restaurant at 8200 Lincoln Avenue and converted it into their headquarters. A year later, the post assumed sponsorship of the Skokie Indians Drum and Bugle Corps, which had moved from Evanston. The Skokie Indians Drum and Bugle Corps, pictured here, were highly successful, winning three consecutive national championships from 1955 to 1957.

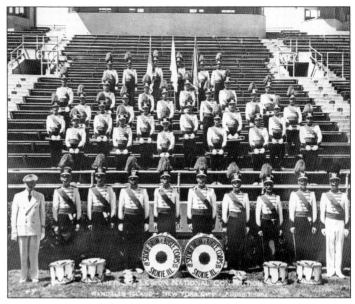

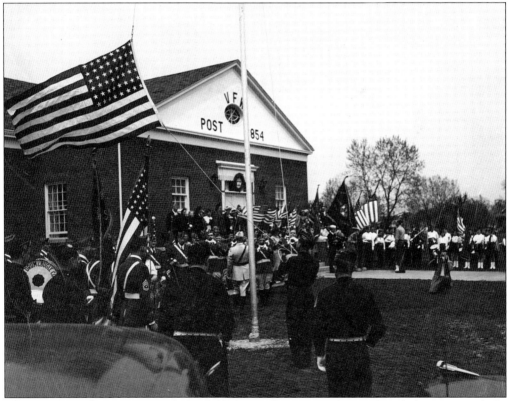

The Veterans of Foreign Wars (VFW) Skokie Valley Post 3854 was founded in 1943 with 79 members. In 1950, the VFW constructed its headquarters at 7401 Lincoln Avenue. Among its many activities, the post sponsored eight little league teams who played their games on the field behind the post. Pictured here are the dedication ceremonies for the VFW headquarters. It is still home to Post 3854 and is now also home to American Legion Post 320.

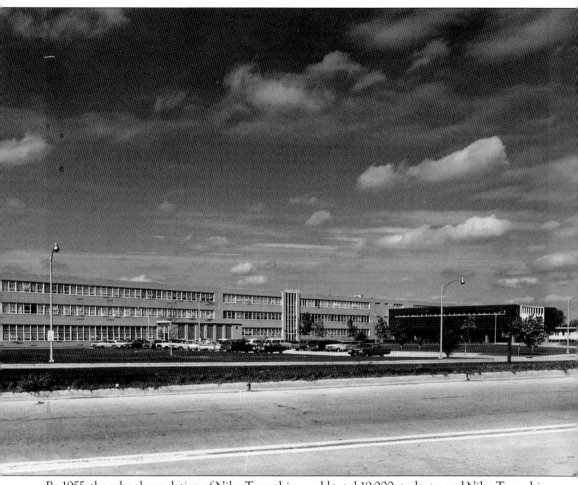

By 1955, the school population of Niles Township would total 19,000 students, and Niles Township High School was no longer able to accommodate incoming students. The need for a second high school building was recognized, and Niles West High School was opened in 1957. The school, pictured here, is located at 5701 Oakton Street. With the advent of Niles West, the name of the original 1939 school was changed to Niles East High School. By 1964, a third high school, Niles North, opened at 9300 Lawler Avenue just west of Old Orchard Shopping Center. With the completion of Niles North High School in 1964, Skokie was home to 21 public schools, four parochial schools, Orchard School for Exceptional Children, and three high schools. Niles East was closed in 1980, and the original high school building was razed in 1993 to make way for Oakton Community College's Skokie campus.

Members of Skokie's Civil Defense organization, founded in 1951, pose during a joint exercise with the Civil Air Patrol in 1961. The photograph was taken at the Skokie Civil Defense airstrip, previously located along McCormick Boulevard between Dempster and Church Streets. The area is now home to Northshore Sculpture Park. Pictured are, from left to right, Frank Pisano, Lester Ascher, two unidentified, Roy France, Kent Williams, John Annoreno, two unidentified, Roy Moore, Fred Tanenbaum, Marshall Massie, and two unidentified. (Courtesy of Lester Ascher.)

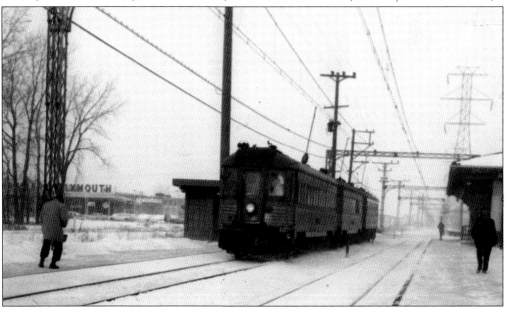

Skokie residents could commute to Chicago by way of the Edens Expressway or the elevated lines of the Chicago Rapid Transit Company, which began operation in 1926. Commuters are braving the cold as they wait for a train car at the Dempster Street Station in 1960. These cars were replaced in 1964 when the elevated line from Dempster Street to Howard Street was inaugurated as the "Skokie Swift." (Courtesy of Robert Louis.)

Skokie was home to many restaurants in the 1950s and 1960s. Pictured above are Michael Hermes and his two children. Hermes was the proprietor of Roundy's Restaurant, which was located at 7738 Lavergne Street across the street from Niles East High School. His father, Paul Hermes, was part of the Hermes family who operated the greenhouses pictured on page 35. Below is the Bays fast food drive-in facility, which was located immediately to the south of Niles East High School at 7625 Lincoln Avenue. Niles East High students certainly had their choice as to where they could pick up fries and a coke. Bays gave way to condos, and when Roundy's restaurant closed its doors, the *Skokie News*, operated by Roland Moore, moved in.

This area of Skokie was originally named Sharp Corner after the intersection of Skokie Boulevard and Gross Point Road. Beginning in the mid-1950s, the area bounded by Church Street on the south, Old Orchard Road on the north, and bisected by Skokie Boulevard, exploded with commercial development, anchored by the Old Orchard Shopping Center immediately north of the area shown. Looking north along Skokie Boulevard, one can see old business standbys like Polk Brothers, B. F. Goodrich, Howard Johnson's, and Turnstyle. At one time, Skokie was home to more than 300 bowling lanes. In addition to the Orchard Bowl, barely visible at the upper left, there was the Edens Bowl at Dempster Street and Gross Point Road, the Oakton Bowl on Oakton Street across from Crafty Beaver, and the Skokie Lanes located at Floral Avenue and Cleveland Street that is pictured on page 68. Unfortunately, all of the bowling establishments were razed to make way for other uses. The last surviving bowling establishment, the Skokie Lanes, was demolished in 2008. (Courtesy of North Shore Photo Service.)

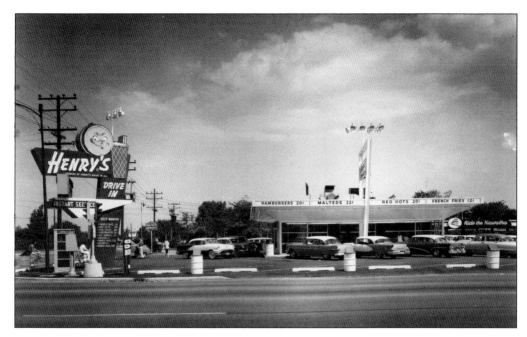

Over the course of its development, the north end of Skokie near Old Orchard Shopping Center has been home to many businesses. Above is Henry's Drive-In, which was located in front of the Skokie Fun Fair Amusement Park at the southeast corner of Golf Road and Skokie Boulevard. From 1960 to 1969, the Fun Fair was owned and operated by Joe and Barbara Jennetten Naegele. Among its attractions was a fire engine, which was used to pick up birthday party guests at their homes and deliver them to the amusement park. This fire engine can be seen on page 95. Below is the entryway to Fun Fair. (Above, courtesy of Mike Kaplan.)

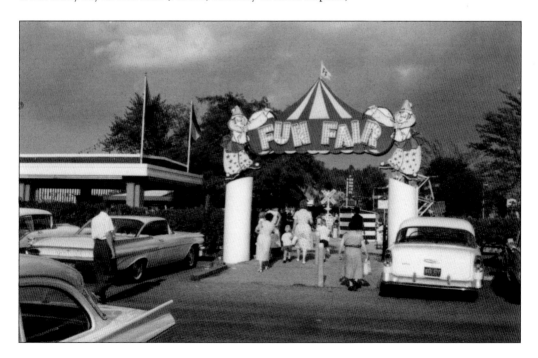

Among the many rides at the Fun Fair Amusement Park were the Hiawatha train ride (right) and the Wild Mouse (below). All of the rides were intended for the toddler and preteen set, as there was insufficient room to offer rides that would capture the attention of thrill-seeking teenagers à la Riverview Amusement Park in Chicago. Also at Fun Fair was an arcade filled with carnival-like attractions. Fun Fair closed its doors in 1969 to make way for the construction of the North Shore Hilton Hotel, which was formally dedicated on October 27, 1973.

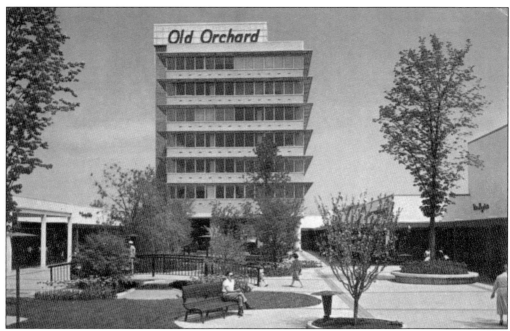

Built by Marshall Field and Company at a cost of nearly $20 million, Old Orchard Shopping Center opened in 1956. The unprecedented open-air mall housed a Marshall Field Department store with 285,000 square feet of retail shopping space as well as many other stores, including The Fair, S. S. Kresge, Kroger, Walgreens, The Country Cobbler, John M. Smyth Company, Montgomery Ward and Company, and C. D. Peacock Jewelry Company. The image above presents a still-recognizable view of the Old Orchard Professional Building and the well-manicured walkway filled with benches and foliage. Pictured in the postcard below are the O'Connor and Goldberg shoe store and the C. D. Peacock jewelry store.

Among the many Jewish community organizations in Skokie were the Niles Township Jewish Men's Club and the Jewish War Veterans, Post 328. Members of the post are posing with Mayor Albert Smith in front of an emergency vehicle donated by the post in memory of the Israeli athletes killed at the 1972 Munich Olympics. From left to right are I. Stoller, S. Fierstein, S. Cohen, Mayor Smith, J. Lome, L. Katznelson, W. London, and M. Abrams.

In the 1975–1976 season, the Niles East sophomore basketball team became the Central Suburban Basketball League Champions. The winning team was, from left to right, (first row) manager Al Davis, Marc Bercoon, Jim Kipnis, Joe Naumes, Mitch Ginsburg, Tom Seimson, Ron Van Roeyan, Mark Arenson, and manager Allen Goodman; (second row) coach Bill Langston, Norm Dellheim, Jeff Frankel, Bill Andrea, Scott Ciran, David Larson, Bob Rubenstein, and Paul Whitmore.

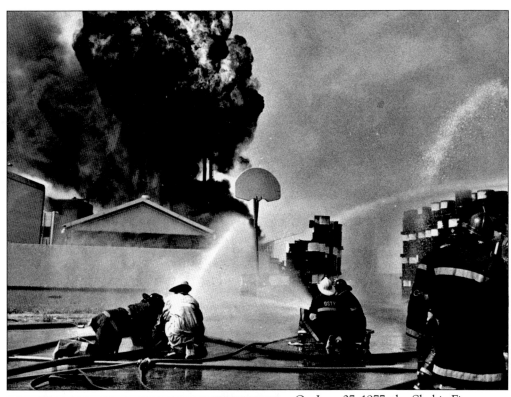

On June 27, 1977, the Skokie Fire Department responded to an extra alarm fire at the G. D. Searle Pharmaceutical Laboratory. This fire destroyed hundreds of barrels of toxic chemicals and, as seen above, sent plumes of smoke high into the sky. Barrels exploded and were propelled nearly 300 feet into the air. Seven firefighters, overcome by fumes, were hospitalized. Four days earlier, on June 23, a five-alarm fire destroyed Skokie Lumberyard's two-story warehouse at 4810 Oakton Street. The fatigue and anxiety of fighting two major fires within four days is clearly shown on the face of Skokie fire chief Jerry Burke, pictured at left on the scene of the Searle fire.

SMASH THE NAZIS!

NO NAZIS ON THE STREETS!

NO FREE SPEECH FOR FASCISTS!

On May 1st at 3 pm, the National Socialist Party of America (Nazis!) will attempt to rally at Skokie City Hall, 5127 Oakton.

Nazis have always stood for genocide against Jews, Blacks—indeed, against ALL "Non-Aryan" groups. Among their recent outrages are firebombing in Marquette Park, the promotion of Arthur Butz's "Hoax of the 20th Century" (which denies the destruction of European Jewry), and establishing a Nazi bookstore in San Francisco's Jewish community. These actions, in addition to their identification with Adolf Hitler, clearly mark them as a fascist gang.

Anti-Semitism, white racism and strike-breaking: the trademarks of Nazism are used by the ruling class to divide the labor movement. In the long run, only the action of working people can defeat fascism. We can begin this May 1st!

JOIN US ON MAY DAY!

RALLY ••• SKOKIE CITY HALL ••• 5127 OAKTON ••• SUNDAY, MAY 1 ••• 2 PM

called by:
Chicago Jewish Committee for Civil Liberties, Chicago Socialist Group, International Socialist Organization, International Socialists, Living Blues Magazine, Red Rose Collective, Red Tide, Revolutionary Socialist League, Revolutionary Steelworkers Caucus, Solidarity Committee Against Apartheid, Surrealist Movement in the United States, Tom Berry Irish Republican Club, Yiddish Literary Club.

For further information call 465-6156

SMASH THE NAZIS!

This flyer, entitled "Smash the Nazis," was handed out by the Chicago Anti-Nazi Coalition. It calls for a rally in front of Skokie's Village Hall to protest the request of the National Socialist (Nazi) Party to march in downtown Skokie. The coalition's protest was to occur May 1, 1977, the same day the Nazi Party planned to march. Even though the efforts of the Nazi Party to march on that day were temporarily stymied by a court injunction, the Chicago Anti-Nazi Coalition still wished to protest, fully realizing that the legal battle was far from over.

Above and below, demonstrators gather outside Skokie's Village Hall to protest the National Socialist (Nazi) Party's request to march in downtown Skokie. In 1976, the Nazi Party, led by Frank Collin, contacted the Skokie Park District to request a permit to march in Lockwood Park. Although this request was never denied, the Nazis turned their attention to the village of Skokie and requested permission to march near Village Hall. The village responded by enacting three ordinances, which, after protracted legal proceedings, were deemed unconstitutional. As a result, the village was compelled to grant the Nazi request and the march was scheduled for June 25, 1978. The march was later cancelled, as the party was given permission to demonstrate in Chicago's Marquette Park. These photographs were taken during the protests in 1977. (Courtesy of David Kantro.)

Cast and crew of the television movie *Skokie* re-create a protest scene in front of Skokie's Village Hall. The film, which aired November 17, 1981, mixed the stories of fictionalized and real characters to depict the events and issues surrounding the National Socialist (Nazi) Party's attempts to march in downtown Skokie. The legal battle between the village, on one hand, and the ACLU and the Nazi Party on the other, as well as efforts of community groups such as the Anti-Defamation League of the B'nai B'rith and the Jewish Defense League, are portrayed. The plot revolved around conflicting responses to the Nazi presence. The characters portrayed by Carl Reiner and Eli Wallach preached that the Nazis should be ignored and they would go away. Danny Kaye, pictured in the center of the cast and crew portraying Holocaust survivor Max Feldman, countered by stating that ignoring the Nazis in the 1930s led to the Holocaust. Others starring in this film were Ed Flanders as Mayor Al Smith, George Dzundza as Frank Collin, Brian Dennehy, and Kim Hunter.

Skokie's Farmers' Market has had many homes over the years. Originally located in the parking lot next to Skokie Lumber at 4810 Oakton Street, the market has since moved to the parking lot between the Skokie Village Hall and Skokie Public Library on Oakton Street. Continuing for over 30 years, the farmers' market is a celebration and reflection of Skokie's distant rural past when the village was home to truck farmers and flower growers. Pictured from left to right are Sam Zabel, organizer; Robert Eppley, village manager; and Mayor Albert Smith. Committed to the community, Robert Eppley served as village manager from 1979 to 1987; Albert J. Smith served as mayor for 22 years, from 1965 to 1987. Smith served as mayor through much of Skokie's suburban development and also guided the village through the momentous Nazi march controversy.

Five

THE INDO-ASIAN ARRIVAL
1981 TO PRESENT

Over the last 30 years, the makeup of Skokie's population has become more ethnically diverse as new families have moved into the area. Many of these families have Indo-Asian origins. Skokie has always welcomed diversity and was, in 1968, the first village in Illinois to pass a fair housing ordinance, which has facilitated Skokie's current melting pot. In an effort to celebrate Skokie's cultural diversity and promote understanding among residents, the Skokie Human Relations Commission, Skokie Park District, Rotary Club of Skokie, Village of Skokie, and the Skokie Public Library began an ethnic diversity project, VOICES (Valuing Our Image Concerning Ethnicity in Skokie), which blossomed into the first Skokie Festival of Cultures. Pictured here, a plaque commemorates this first Festival of Cultures alongside a circle of flags located at McCormick Boulevard and Dempster Street in the Skokie Northshore Sculpture Park. At the northeastern boundary of Skokie, the flags welcome visitors and are a reflection of the many cultures that have come to call Skokie home. (Courtesy of John Zouras Photography.)

Mayor Albert J. Smith, village clerk Marlene Williams, and local business and civic leader Archel Hanson, seated at right, join members of the Chinese Language School and Chinese Cultural and Education Association to celebrate the Chinese New Year in the 1980s. Samuel S. Kung, Ph.D., the former chairman of the board of the Chinese Language School and Chinese Cultural and Education Association is standing at right.

On October 24, 1987, the Luxembourg Brotherhood of America celebrated its centennial at the North Shore Hilton in the presence of then Crown Prince Henri of Luxembourg, now the reigning grand duke. Pictured with Crown Prince Henri (seated fourth from left) and Crown Princess Maria Teresa are the officers of the LBA, among whom are Skokians Richard J. Witry, standing fourth from the left; Lawrence F. Molitor, standing sixth from the left; and Donald J. Hansen, seated at far left.

In the summer of 1988, the Village of Skokie held a three-day festival in celebration of its centennial. Pictured are participants in the parade held on Sunday, August 14, which was the hottest day of the year. The parade travelled from Oakton Community College via Lincoln Avenue to Oakton Street and then proceeded to Niles West High School. Surviving high humidity and 95-degree heat, the Niles North High School cheerleading squad (above) rallies onlookers, while below, members of the Filipino American Coalition of Niles Township wave from their truck. The cultural diversity of the cheerleading squad and the Filipino American Coalition of Niles Township demonstrate Skokie's growing diversity.

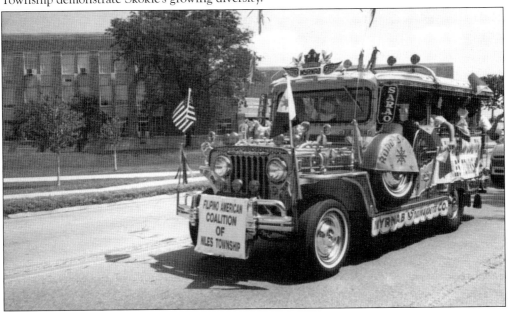

From July 11 to July 17, 1990, the Skokie Park District hosted the Vietnam Veterans Memorial Moving Wall at Oakton Park. Pictured above, community leaders Dan Brown, park district director; Martin Peccia, park district board president; Rev. Charles F. Cronin, pastor at St. Peter Catholic Church; and Mayor Jacqueline Gorrell participate in the opening ceremonies. The speaker and the woman to his right are unidentified. Visitors, pictured below, view the wall that contains the names of the 58,000 soldiers, sailors, and marines who gave their lives during the Vietnam War. In the 1990s, the Skokie Park District flourished in response to Skokie's changing community. Besides sponsoring the Moving Wall, the district sponsored the Festival of Cultures, opened the Skokie Heritage Museum in 1992, completed Weber Leisure Center in 1995, and in 1997, won five awards for excellence at the Illinois Parks and Recreation Association convention, among which was the National Gold Medal for Excellence in Park and Recreation Management.

Skokie's Jewish community has contained many Holocaust survivors. In order that neither the tragedy of the Holocaust nor the outrage of the attempted Nazi march be forgotten, the Holocaust Memorial (right) was created and placed in the Village Green. The memorial was dedicated on October 20, 1988, with Gov. Jim Thompson and Pres. George H. W. Bush in attendance. Depicted below is the Illinois Holocaust Museum and Education Center, located at 9603 Woods Drive. In response to the Nazi Party's attempts to march in Skokie, the Holocaust Memorial Foundation of Illinois was formed in 1981. The foundation's original museum, located on Main Street, was replaced in April 2009 by the grand structure pictured here. Former president Bill Clinton and Nobel Peace Prize winner and Holocaust survivor Elie Wiesel were among the many featured speakers at the dedication of the new museum building. (Courtesy John Zouras Photography.)

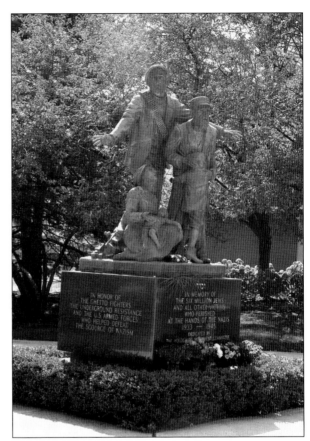

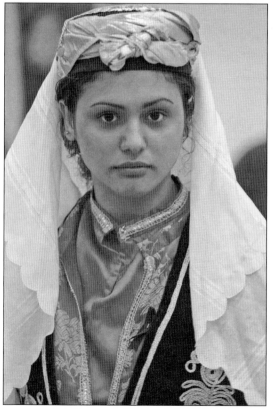

Members of the 2004 Skokie Festival of Cultures Committee are pictured above singing during opening ceremonies. Pictured are, from left to right, (first row) Maria Garcia, Cuban community; Krishna Goyal, Indian community; Shyam Bindal, Indian community; and Juliana Livieri, Mexican community; (second row) Art Mikaelian, Armenian community; Javed Bhatty, Pakistani community; Elizabeth Kessler, former chairperson; Roy Erik Swenson, Swedish community; Gary Kenzer, Israeli community; and unidentified. During the opening ceremonies, participating cultures dress in authentic cultural garments and present their flags, which are displayed during the event. Pictured at left, Emel Hocaoglu, from the Turkish community, participates in the ceremony. The Skokie Festival of Cultures, which is celebrating its 20th year in 2010, continues to grow. During the 2009 event, approximately 30,000 attended. (Courtesy of the Skokie Park District.)

Not only do Skokie's newest citizens live here, they have become integrated into its business community as well. Pictured above is Pam Panya, owner of Tub Tim Thai restaurant, located at 4927 Oakton Street. Depicted below is Ace Hardware owner Paul McGivern with Mehul "Mike" Patel, a native of India. The Ace Hardware store, located at 5035 Oakton Street, began operations as the Niles Center Mercantile Company around 1907, became affiliated with the Ace Hardware cooperative in 1928, and continues to operate as Skokie's oldest continuously operating commercial establishment. Compare this building to those pictured on page 53. (Courtesy of John Zouras Photography.)

Among the larger ethnic groups to call Skokie home is the Indian community. On October 2, 2004, members of this group and other Skokians gathered at Heritage Park, located near McCormick Boulevard and Church Street, to dedicate this statue of Mohandas Gandhi, recognized as the spiritual leader and founder of modern India. Born in 1869, Gandhi was a trained lawyer who was exposed early on to the unfairness of the British system in the treatment of the nonwhite members of the British Commonwealth of Nations. Adopting the principles of nonviolence and civil disobedience, he fostered the idea of Indian independence, which was eventually granted by the British in 1947. In contrast to the spirit of peace and brotherhood for which Gandhi stood, he was killed by a Hindu fanatic opposed to the precepts by which Gandhi lived his life and for which Gandhi gave his life. (Courtesy of John Zouras Photography.)

The entrance to the Skokie Public Library reflects Skokie's ethnic diversity. The phrases "welcome" and "library" are written in various languages familiar to Skokie residents. In 2008, in recognition of its standing as one of the premier public libraries in the United States, the library was awarded the National Medal for Museum and Library Services, one of only 10 libraries and museums in the entire country to receive this award. (Courtesy of Ruth Sinker, Skokie Public Library.)

In late August of every year, the Independent Merchants of Downtown Skokie (IMODS) and the Skokie Park District, in cooperation with the village, present the Backlot Bash, a festival celebrating Skokie's heritage as an early film stage. From around 1905 to 1915, Niles Center served as a backlot for the production of westerns filmed by the Essanay Film Company of Chicago. Pictured above, the marquee of the Skokie Theater advertises the presentation of silent movies sponsored by IMODS. (Courtesy of John Zouras Photography.)

The Backlot Bash is a three day event held in downtown Skokie and requires the closure of Oakton Street from Lincoln Avenue west to Laramie Avenue. It features free music, carnival rides, a 5K run/walk, silent movies, arts and crafts show, beer tent, classic car show, bingo, and food. During the bash, the Skokie Heritage Museum and Log Cabin are open to the public. The museum's collection includes the original 1865 Rumsey pumper first owned by the Niles Centre Volunteer Fire Company (depicted on page 4), a hose cart, and a re-created ladder wagon from around the 1880s. A symbol of community cooperation, the bash entertains residents and raises awareness of Skokie's downtown business district. Pictured here in front of Skokie's Village Hall and Village Green are blues legends Lonnie Brooks and Eddie "The Chief" Clearwater, a Skokie resident, entertaining a large crowd at the 2008 bash. Attendance in 2009 approached 35,000. (Courtesy of the Skokie Park District.)

BIBLIOGRAPHY

Beaudette, E. Palma. *Niles Township*. 1917.

Buisseret, David and Gerald Danzer,. *Skokie: A Community History Using Old Maps*. Chicago, IL: Chicago Neighborhood History Project, Skokie Historical Society and Newberry Library, 1985.

Clifton, James A. *The Potawatomi*. New York, NY: Chelsea House Publishers, 1987.

Edmunds, R. David. *The Potawatomis: Keepers of the Fire*. Norman, OK: University of Oklahoma Press, 1978.

Encyclopedia Britannica, Fifteenth Edition, 2007. Chicago, IL: Encyclopedia Britannica, Inc.

Hagedorn, Jane and Richard J.Witry, editors. *Chronology of Events: Niles Township, Village of Niles Center/ Skokie, 1500 AD–2000 AD, Second Edition*. Skokie, IL: Skokie Historical Society and Skokie Public Library, 2000.

Skokie Historical Society Documentary and Pictorial Archives. Skokie, IL.

Smith, Ron. *Skokie Fire Department Chronology*. Self Published, 2007.

Vogel, Virgil J. "Indian Place Names in Illinois." *Journal of the Illinois State Historical Society, Vol. LV*. Springfield, IL: Illinois State Historical Society,1962.

Whittingham, Richard. *Skokie: A Centennial History*. Skokie, IL: Village of Skokie, 1988.

Witry, Richard J. *Luxembourg Brotherhood of America, 1887– 1987*. Chicago, IL: Luxembourg Brotherhood of America, 1987.

www.arcadiapublishing.com

MAP SEARCH

Discover books about the town where you grew up, the cities where your friends and families live, the town where your parents met, or even that retirement spot you've been dreaming about. Our Web site provides history lovers with exclusive deals, advanced notification about new titles, e-mail alerts of author events, and much more.

Find Your Place in History.